Praise for Paul Stephen Hudson and Lora Pond Mirza's
Atlanta's Stone Mountain: A Multicultural History

"It is hard to imagine another natural site that has engendered as much social, political and cultural history as has Stone Mountain. Paul Hudson and Lora Mirza capture all of that and much more in this engaging and fully realized portrait of this granite phenomenon, past and present. Full of new information and fresh perspectives, this is as complete and multifaceted a treatment of the mountain and its history yet, and it is a major contribution to both Atlanta and Georgia history."

John C. Inscoe
Editor
The New Georgia Encyclopedia

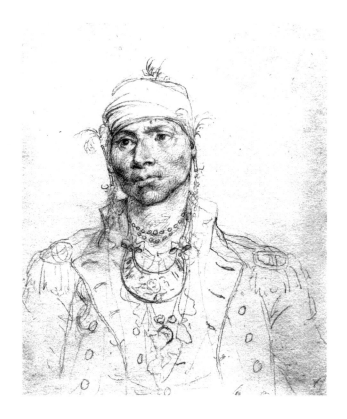

A drawing believed to be Muscogee-Creek Indian mico (or chief) Alexander McGillivray in Native American and U.S. military dress, rendered by noted artist John Trumbull. In 1790, McGillivray signed the treaty of cession, making Stone Mountain property of the State of Georgia. *Courtesy of Fordham University Libraries.*

Atlanta's STONE MOUNTAIN

A MULTICULTURAL HISTORY

PAUL STEPHEN HUDSON
& LORA POND MIRZA

Paul Stephen Hudson
Lora Pond Mirza

Charleston London

THE
History
PRESS

Published by The History Press
Charleston, SC 29403
www.historypress.net

Front cover: Panorama of Stone Mountain and Stone Mountain Lake, with rocks in foreground. *Photo by Lora Mirza.*

Back cover: Photographic montage of Stone Mountain (from top): Confederate Memorial carving on the north face. *Photo by Ren Davis*; Elias Nour drives a truck down the mountainside. *Elias Nour Collection, courtesy of George D.N. Coletti*; cyclists pose at Walk-up Trail. *Photo taken by a stranger*; yellow daisies grow on the mountain slope. *Photo © Larry Winslett.*

First published 2011
Manufactured in the United States

ISBN 978.1.59629.682.4

Hudson, Paul Stephen.
Atlanta's Stone Mountain : a multicultural history / Paul Stephen Hudson and Lora Pond Mirza.
p. cm.
Includes bibliographical references and index.
ISBN 978-1-59629-682-4
1. Stone Mountain Memorial State Park (Ga.)--History. 2. Stone Mountain Memorial State Park (Ga.)--History--Pictorial works. 3. Stone Mountain Memorial (Ga.)--History. 4. Stone Mountain Memorial (Ga.)--History--Pictorial works. 5. Atlanta Region (Ga.)--Social conditions. 6. Atlanta Region (Ga.)--Ethnic relations. 7. Cultural pluralism--Georgia--Atlanta Region--History. 8. Ethnology--Georgia--Atlanta Region--History. I. Mirza, Lora Pond. II. Title.
F292.S85H83 2011
975.8'231--dc22
2011011140

Notice: The information in this book is true and complete to the best of our knowledge. It is offered without guarantee on the part of the authors or The History Press. The authors and The History Press disclaim all liability in connection with the use of this book.

To Julie Jarrard, sweetheart and photographer, and in memory of her dog, Tonto; and to Paul's sister, Kathy Wilkerson, and her husband, John, in Chattanooga, golfers at Stone Mountain Park;

To Usman Mirza, darling husband and our Most Valuable Player; and to Lora and Usman's sons: Taric Mirza, and his wife, Madigan McGillicuddy, in Atlanta; and Adam Mirza, in New York City;

To all dear family and loved ones, thank you for your ongoing encouragement and support;

And to all of the 4 million annual visitors to Stone Mountain Park, including those in Atlanta who go there frequently, some daily, and love it as we do.

To all of you we dedicate this multicultural history of Stone Mountain, with affection deep and true.

Contents

Acknowledgements

Th here is an old saying that no one ever does anything by oneself, and never was the case truer than with our book. Here we gratefully acknowledge more than a little help from our friends.

To George and Susan Coletti, who so graciously welcomed us into their Stone Mountain home many times and who invited other members of the village community to meet and talk with us. Gathered around the Coletti family table were Dot Guess, Raymond W. (Billy) Hicks, Hugh Jordan, Henry Shoemaker, Bill and Will Simmons and former Stone Mountain mayor Gary Peet. Gary has shared stories, letters, images and scrapbooks of his grandfather, C.J. Tucker, who worked on the Stone Mountain carving. We thank you all. And to George and Susan, again, for sharing a treasure-trove of magnificent scrapbooks of George's uncle, Elias Nour, and a thorough knowledge of Stone Mountain, the park and the city. Your understanding of Stone Mountain historical artifacts is beyond measure. You are inspirations to us, and we are honored to be your friends and have been overwhelmed by your generosity.

To Larry Winslett, preeminent nature photographer ("It's all about the light!") of the Southeast, whose images of Stone Mountain wildlife and the Great Rock itself grace many pages in our book. Larry's nature walks have informed us all.

To Curtis Branscome of the Stone Mountain Memorial Association; we are deeply appreciative of the public spirit of SMMA. It provides a safe and instructive environment for all who visit Stone Mountain Park in pursuit of

nature, history and recreation. To Naomi Thompson, SMMA educator, we thank you for your thoughtful review of our project and for your concern that we get it right. You lead a wonderful staff.

Our thanks to the dedicated staff at Stone Mountain Park, who make guest visits such a joy, beginning with the friendly waves at the entrance gates and promising exciting adventures every time.

To Melissa Forgey, Jill Sweetapple and Kenneth Thomas Jr. of the DeKalb History Center; to fellow member Jennifer Richardson, who graciously shared her attic treasures about Stone Mountain; and to Mary Beth Reed of New South Associates in the city of Stone Mountain, who has immense knowledge of the area. To our friend Joe Dabney, award-winning folklorist, Atlanta author and southern gentleman. To Carrie Jacobs Henderson for our rare Civil War map. To the Atlanta History Center; to Steve Engerrand, Georgia Archives; to Stan Deaton and Edwin L. Jackson, Georgia Historical Society; to Columbus Brown, photographer; to Historic Oakland Cemetery lovers (not as morbid as it sounds) Ren and Helen Davis, for photographs of Stone Mountain Park; and to Wynn Montgomery. To Paul's niece and photographer, Jennifer Wilkerson; to Lora's sisters, Beth White and Tina Pond, for careful readings of early chapter drafts; in loving memory of our brother, Rick Pond, who was so excited about this project; and to Ulrike Ackerman and her husband, Michael.

To Taylor Studios, Inc., Rantoul, Illinois, whose representations of continent formation, of Stone Mountain formation and of early hunters grace our book; these images can be seen full size at the Confederate Hall Museum at Stone Mountain Park.

To Wood Ronsaville Harlin, Inc., Annapolis, Maryland, whose glowing illustration of the turtle roast by Rob Wood helps us visualize native peoples of earlier times.

To Bernie Jestrabek-Hart, Nampa, Idaho, whose painted aluminum sculptures of red-tailed hawks, based in part on careful research of hawk wings available at the Burke Museum of Natural History and Culture, University of Washington, Seattle, capture the spirit of these magnificent birds.

All of you went the extra mile for us.

To Adam Ferrell, publishing director at The History Press, and Ryan Finn, project editor, and to all staff who saw us through this book we love.

To all of our colleagues at Georgia Perimeter College (GPC): Professor Rosemary Cox, for her essay on her father's role at Stone Mountain; Professor Steve Koplan, who brought humor to image review; Professor Gayle Christian, who researched local geology; Professor David Champa,

who arranged our 2010 presentation to the Stone Mountain Rotarians; Professor Carmel Brunson, for technical assistance; Professor John Siler, for the humor provided; and to many other colleagues and friends. Special thanks to Akiko for tea and sympathy.

To the GPC Marketing and Public Relations team, led by Barbara Obrentz, for continuing support. "Technological thanks" go to Nelson Young, for his outstanding assistance. Our thanks also go to the GPC Department of Public Safety for making the library available for research and fact checking as deadlines drew closer.

To Professors Rob Jenkins and Jack Riggs, Georgia Perimeter College Writers Institute, for facilitating a 2010–11 Writers Faculty Fellowship for Paul; to Professor Liam Madden, GPC Southern Academy for Literary Arts and Scholarly Research, for the support of the academy; to our students, who followed our project with great enthusiasm; to our supportive department chairs Karen Wheel-Carter, social sciences, and Joseph Barnes, library director, with special thanks to Joe for his careful reading of our manuscript; and to Anthony Tricoli, president of Georgia Perimeter College.

We thank you all!

Introduction

Going to Atlanta's Stone Mountain Park, whether for the first or one hundredth time, is always an adventure. The vista of a majestic gray granite dome more than eight hundred feet high and the length of four football fields inspires awe. Some Atlantans say that they take Stone Mountain "for granite," but it literally rocks anyone but the most jaded viewer. Gazing from a distance at the gargantuan, primal and smooth but scarred mountain, one almost feels like an early Native American. This intuitive sensation is perhaps because Stone Mountain has been in existence for a mind-boggling 280 million years.

Georgians enthusiastically visit Stone Mountain, which has been a park administrated by a state authority since 1958, to enjoy its natural beauty and recreation. A perennial draw for runners, joggers, walkers and cyclists, the park offers the perfect five-mile course around the mountain. Park festivals and other events, including the Highland Games and Indian Festival and Powwow, are nearly legendary. People come to Stone Mountain even in the winter. In the milder seasons, families gather at dusk on Memorial Lawn to watch the evening laser shows beamed onto the mountain. Stone Mountain attracts an impressive 4 million visitors per year.

We can only speculate about the first people ever to see Stone Mountain, in the mists of prehistory during the early ages of humankind. They were most likely Paleo-Indians before there even were tribes, very much like modern people in physique and part of a movement of indigenous extended

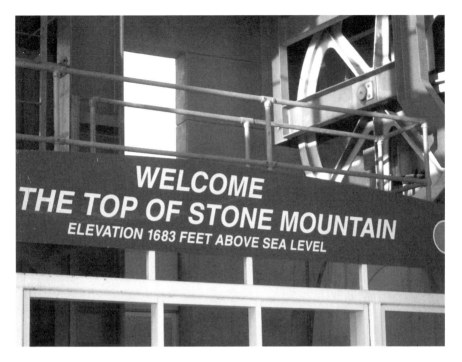

The mountaintop sign at the end of the Skyride welcomes and informs Stone Mountain Park visitors. *Photo by authors.*

families that traveled across the eastern seaboard of America about nine or ten thousand years ago. These pre-Columbian people probably ran, jogged or walked in highly mobile bands of about twenty to fifty members, with no animals except perhaps a dog. They were hunters and food gatherers and foraged for wild beasts such as mammoths or mastodons, which once roamed the wilderness of what we call Georgia.

As these people ran animals down, they exhausted their prey before going in for the kill with throwing sticks and stone-headed spears; later they perhaps used sleds for transport. Upon first seeing the huge dome-shaped rock in the distance, it would have been natural for the Indians to stop dead in their tracks—Stone Mountain has that effect—and then to quicken their pace to get there. Perhaps with hearts racing they saw the mountain in the early light from the rising sun. Certainly they were compelled to do what many visitors have done and continue to do every single day of the week for decades, in recent times and throughout the ages: climb to the top. And the wolflike quasidomesticated dogs with the Paleo-Indians were likely the first to reach Stone Mountain, where people love to walk their pets today.

Today's traveler nearing Stone Mountain temporarily loses sight of the great bluish-gray granite dome. It rears up again in view at the approach of East Ponce de Leon Avenue, a section of one of Atlanta's great road arteries, which connects Stone Mountain with the city. Parallel to the road is the Freedom Trail, an urban, ecologically friendly paved route that is part of a trail system linking Atlanta with Stone Mountain. Cyclists in particular swarm the trail, perhaps taking variations of routes that Native Americans took to get to Stone Mountain. The roads lead to the charming Stone Mountain Village, a settlement that was established in antebellum times in the 1840s. Georgians realized then that Stone Mountain was remarkable as a destination for tourists. Today, as one gets closer, the main attraction does not disappoint, and the environs are beautifully maintained.

Visitors are sometimes surprised by what seems like an incongruous memorial to the Old Confederacy, for which there is more than a half-century tradition at Stone Mountain. Indeed, there is a

Representation of wild mammoths of the type that Paleo-Indians hunted in prehistoric times. *Image © Taylor Studios, Inc., Rantoul, Illinois.*

legislative mandate from the State of Georgia to foster its heritage as a Confederate memorial, which is carried out by the Stone Mountain Memorial Association, established in 1958. The greatest symbol in this regard is a massive carving on the north face of the mountain depicting the Confederate heroes Jefferson Davis, Robert E. Lee and Stonewall Jackson—none of them Georgians. It is one of the many compelling stories of Stone Mountain, bringing together art, history and technology.

The carving necessarily takes on a special significance in the 2011–15 remembrance of the 150th anniversary of the American Civil War. But Atlanta, Georgia, and the United States have become so much more diverse than they were in 1915, when the Confederate Memorial carving was conceived by the Atlanta chapter of the United Daughters of the Confederacy. In 1970, after many fits and starts, the carving received its final dedication. The world has changed dramatically since then, and so has multicultural America, as it continues to seek its promise. In the twenty-first century, Stone Mountain Park has become a remarkably open place that people of all ages, abilities and cultures enjoy and that serves as a continual place of delight.

In this multicultural history of Stone Mountain, we deal with various periods of time that have special characteristics that can help us understand a multitude of important, lovely and enduring things. We offer an affectionate portrait of a place we love that is always, but especially on beautiful southern days, burnished with such special light. Nevertheless, idyllic Stone Mountain has one significant and historic dark side—it hosted the symbolic revival of the Ku Klux Klan at its summit one cold November night in 1915—and we are not unmindful of it, nor should we be. Indeed, Klansmen held Stone Mountain Village as a special place as well and had a marked presence there until the 1970s. In contemporary times, Stone Mountain made international history in 1996 when it welcomed the world as an Olympic venue for archery, track cycling and tennis.

In our quest to construct not only a multicultural history and contemporary survey but also a guide for curious readers, we want always to keep Stone Mountain in perspective. It is a wondrous place that still has primeval grandeur and natural botanical beauty, along with spectacular wildlife. It is visited daily by thousands for recreation or tourism and offers history lessons galore. The Stone Mountain Memorial Association has recently added to its mission an environmental science

and education interpretive function that has been most useful in helping us learn. We must, in all sincerity, express gratitude for the wonderful gift of Atlanta's Stone Mountain through the ages.

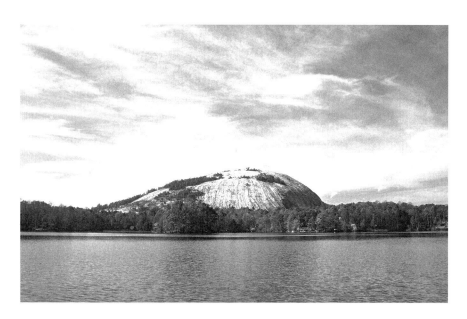

Beautiful and contemporary Stone Mountain Park, with man-made Stone Mountain Lake in foreground. *Photo © Larry Winslett.*

Cosmic Rock of Ages and a Native American Heritage

Primeval Stone Mountain, standing today surrounded by modern beautiful park environs, all perched atop a high ridge about sixteen miles east of Atlanta, Georgia, presents an appearance unlike anything in the world. Rising from the gently rolling Piedmont region, Stone Mountain has an elevation that on some days

STONE MOUNTAIN
More than 800 feet high
1.3 miles long
0.6 mile wide
Covers 583 acres
1,683 feet above sea level

reaches the clouds. Its nearest mountain neighbor, Kennesaw, is more than thirty miles away, so Stone Mountain contrasts vividly with its surrounding countryside in an increasingly densely populated area of DeKalb County. The mountain, really a huge granite outcrop, has a striking appearance because of a nearly perfect natural symmetry. This enormous rock, shaped like a dome or a gigantic egg on its side, is ancient—about 280 million years old. Stone Mountain, one of the largest masses of isolated, exposed granite in the southeastern United States, began in a great vortex of geological time when two continental landmasses collided.

LIFE BEFORE PEOPLE:
STONE MOUNTAIN THROUGH THE MILLENNIA

The origins of Stone Mountain date from geological events in flux nearly 300 million years ago. Drifting continental forms that would become North America and Africa were on a collision course, but not as quickly as we might imagine—rather, the continents were moving slowly, inexorably headed for their colossal clash.

Intense heat had radiated from Earth's inner core, driving the continental movement. As the two great landmasses drifted closer, it was so slow as to be nearly imperceptible, a pace of centimeters per year—about the rate that fingernails grow. The continental collision, however, was cataclysmic. The ocean floor between the drifting continents opened and closed. Because the crusts and lower levels of rocks under the earth rested on a mantle with the consistency of warm putty, the impact increased even more.

The force of the two continents colliding was so tremendous that after forming the Appalachian Mountains the area continued to flame with heat and pressure underground. These scorching forces continued to buckle the fractured earth. On the southern plateau sixty miles south of the Appalachians, what we now call the Piedmont ("foot of the mountains"), Stone Mountain came to be. More

Representation of continental drift of North America and Africa in geological time. *Image © Taylor Studios, Inc.*

Continental collision in geological time, leading to formation of Stone Mountain as a huge boulder underground. *Image © Taylor Studios, Inc.*

than eight miles below the earth's crust, a huge mass of hot liquid rock called magma formed. This was a grand consequence of the landscapes in motion. The fiery, glowing mass that eventually became Stone Mountain simmered, forcefully compressed under layers and folds of the earth.

Rock of Ages

After cooling for a few million years, to be inexact, the great magma mass solidified and crystallized, or hardened, under high temperatures and pressure. It transformed into a huge coarse-grained rock, granite, unmoved and still about eight miles or so underground. The formation became what geologists term an "intrusion" below the earth. The huge primordial granite egg incubated through eons of geological time. It lay hidden during the Jurassic period about 200 million years ago, when the great plant-eating dinosaurs roamed the earth and birds and frogs began to appear.

The "Great Rock" remained underground during the Tertiary period, about 20 million years ago, when reptiles and some plants began to appear,

Large boulders broken off from Stone Mountain. *Photo © Larry Winslett.*

Representation of Stone Mountain as huge boulder underground after molten rock cooled. *Image © Taylor Studios, Inc.*

even as the continents slowly moved back into their current global positions. In due course, a significant part of the rock ended up *atop* as well as *below* the earth. Erosion, the process whereby natural forces attack and eat into the surface of the land, was the operative force at work. The granite formation never erupted from the landscape, but rather the earth eroded to uncover Stone Mountain. Neither rivers nor oceans were near the Stone Mountain site. Its main erosive forces—sun, rain, frost and wind—were more subtle and slower. As the earth's surface above the Great Rock began to erode, the huge granite mass—looking somewhat like a giant whale and destined to become Stone Mountain—emerged.

Over millions of years, the sizable granite mass became increasingly exposed as a kind of large rock hill. By 10 million years ago, there had been enough erosion that an impressively visible rock—and somewhere about this time we can call the *aboveground* formation Stone Mountain—appeared quite high above the earth's crust, standing perhaps a little more than two hundred feet. About one-quarter the height that it is today, the young Stone Mountain was to continue to stand tall against erosive forces over the coming millennia. By the Quaternary period, about 1 million years ago, the promontory had become a fixed feature of the Piedmont region of Georgia. As erosion continued, Stone Mountain emerged above its surrounding landscape over thousands of years, eventually gaining its present height as a commanding

HARD AS ROCK

Granite is igneous rock, meaning it forms deep underground, where it solidifies under high temperatures and pressure. Granite is abundant in subterranean forms, but rarely is it exposed on a plateau landscape as dramatically, in such enormous size or symmetrical shape, as at Atlanta's Stone Mountain.

Called the "rock of ages" because of its strength, granite is typically composed primarily of the minerals quartz, feldspar and mica. All except mica approach the hardness of steel. Granites are usually red, pink or gray depending on the color of the feldspars. Stone Mountain is gray.

Positively surreal: the uncanny "moonscape" surface of Stone Mountain. In 1974, astronaut John Young, Georgia Tech alumnus and Apollo 16 commander, dubbed a hilly area of the moon's Descartes Region as Stone Mountain. *Photo © Larry Winslett.*

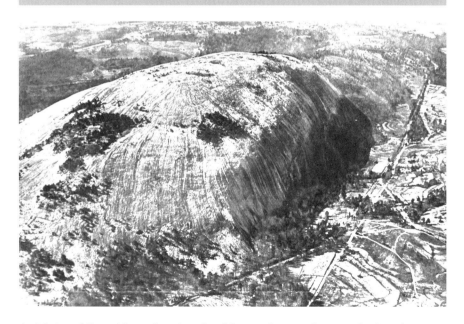

Aerial view of Stone Mountain as it surfaced from underground as a result of erosion. *George D.N. Coletti Collection.*

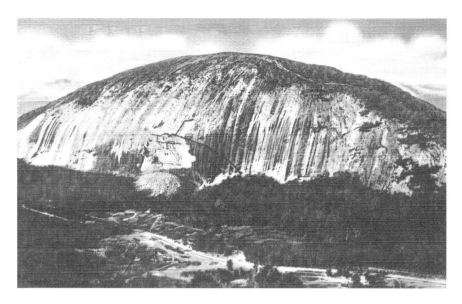

Vintage postcard of mountain dome with prehistoric scars. *George D.N. Coletti Collection.*

presence in the southeastern region of what would be called America. When Europeans first saw Stone Mountain, it probably towered about eight hundred feet high, more or less its height today.

Seeing Stone Mountain today is revealing. Enormous as it is, about half of it is still underground as the bottom half of a great rock. And some of the long "scars" on the exposed granite are up to 300 million years old!

THE STONE MOUNTAIN "DOME"

Nature's toll—wind, rain, frost and the sun—continued at Stone Mountain in the form of weathering. This destructive force was physical, with cracks breaking the rock, and chemical, with changes in composition. There has also been significant human impact over the last two hundred years, with granite quarrying, an epic memorial carving, sky-ride construction and countless footsteps. (But don't let that ruin your hike to the summit!)

Extensive exfoliation, or flaking, has taken place. As the Great Rock surfaced, the mountain expanded outward aboveground. In doing so, its

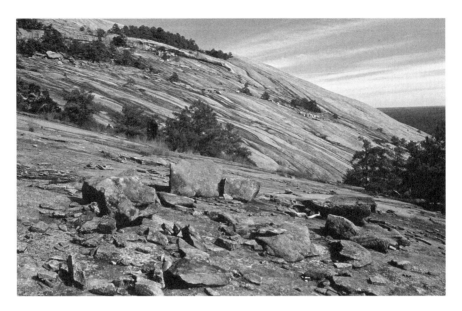

South slope of Stone Mountain with rocks broken off, showing exfoliation. *Photo ©
Larry Winslett.*

surface loosened into onionlike layers that can be seen clearly in the old
quarries. A weathering process called "exfoliation sheeting" causes peeling
of the surface layers of Stone Mountain, resulting in tapers on all sides that
led to the pleasing symmetrical dome shape that we see today.

ATLANTA'S STONE MOUNTAIN:
MIGHTIEST OF THE MONADNOCKS

Because Stone Mountain stands alone and was uncovered through the
process of erosion, geologists have a special term for it and other such
formations. They are called "monadnocks."

In north Georgia's DeKalb County, there are smaller monadnocks in the
general area of Stone Mountain, such as Panola Mountain. These unique
habitats are sometimes called "granite outcrops." Nearby Arabia Mountain
is composed primarily of gneiss (pronounced "nice"), an igneous rock not
as hard as granite. Various small, unnamed granite outcrops abound around
the base of Stone Mountain.

Although there are many monadnocks, none is made exclusively of granite like Stone Mountain. Kennesaw Mountain in Georgia stands an impressive 1,808 feet but is composed of elongated belts of sedimentary and volcanic rocks. Mount Monadnock in Jaffrey, New Hampshire, at 3,165 feet, is even higher. Extremely popular with hikers in the United States, this mountain is sometimes called Grand Monadnock to distinguish it from other variations of the monadnock name in New England. It is made of metamorphosed (transformed) rocks, primarily schist. The monadnock Uluru in Australia stands at 986 feet and is formed of beautiful red sandstone.

Although not the largest of the monadnocks, Stone Mountain is to its fans the mightiest, for it is the only solid, rounded and tapered isolated dome-shaped granite mass in the world, with no mountains nearby. Stone Mountain is a bold, bald free agent connected to no mountain chain. Stone Mountain is to its lovers the wonderfully arguable "Eighth Wonder of the World."

Atlantans are notorious as unabashed boosters of their city. Since nothing will ever change the minds of such devotees, amounting almost to a cult, regarding the magnificence of Stone Mountain, millions of visitors in the sprawling metropolitan Atlanta area continue to pour through its park gates. Their "identity cards" are annual windshield stickers that merit an inviting

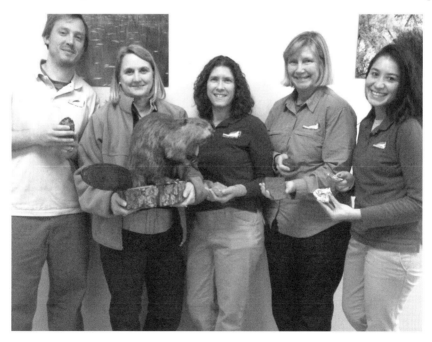

Geologist Naomi Thompson (center) and staff at Confederate Hall Environmental and Education Center. *Photo by authors.*

wave from friendly staff at the gates of Stone Mountain Park. Allowing unlimited access to the park for a year, these passes are one of the best values in Atlanta. World travelers put Stone Mountain on their "must see" lists as well, and day passes may also be purchased. Tour buses are nearly always at the park, for one constant is that as long as there have been people, they have loved to visit that big old granite mountain.

INDIAN PREHISTORIC TIMES AT STONE MOUNTAIN

It is nearly impossible to contemplate the age and mystery of Stone Mountain without thinking of the ancient peoples who originally inhabited the area. Those Indians who were natural poets, according to tradition, praised the bald mountain, with its variously stark and shiny appearances. Because Stone Mountain is so majestic and awe-inspiring, it related to their mythological speculations about the creation of the world, most likely echoes of the oldest prehistoric native stories. Unlike the creation epics of Judaism, Christianity and Islam, the first American religions were neither written nor had specific founders. Native American mythology was intensely mystical, allowing people to have direct contact with the supernatural through visions or dreams. Indian religion is often described as animistic—it reverenced a close bond among people, animals and nature, all living in harmony.

It was natural for prehistoric people in America, as throughout the world, to worship the sun. As people became conscious of their surroundings, they realized that light and heat are indispensable to life on earth. A transcribed Cherokee legend in Georgia begins: "In the old days the beasts, birds, fishes, insects and plants all could talk." As this legend relates, the earth was dark and very flat, soft and wet, so all living things sent the Great Buzzard out, urging him to make ready for them. As he scouted the dim wetlands, he flew low all over the earth, the story goes, and the ground was still soft. The buzzard became very tired, and his wings began to flap, sometimes striking the ground. Wherever this happened, there was a valley. When his wings turned up, he created a mountain. When the other birds and animals came down to view the earth with its mountains, valleys, plateaus and plains, they were pleased to see that it was finally dry, but the sky was still dark. So, needing light, they set the Great Sun in a track to go across the land from east to west. Indians believed that inanimate objects had spirits, so they may have thought that Stone Mountain was not only an important life

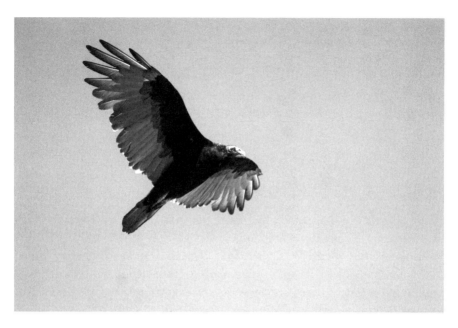

Turkey vulture or buzzard as described in Cherokee legend. *Photo by Callie Bowdish.*

force but also a destination to closely encounter cosmic solar radiance. Stone Mountain was perhaps a place to get closer to the heavens.

Like early Native Americans, people from all over the world experience the sun atop the Stone Mountain summit today, sometimes staring with new perspectives at ever changing clouds as red-tailed hawks circle overhead in daytime and great horned owls at twilight. (Before their near extinction, eagles flew over Stone Mountain as well.) Indians believed that clouds were also creatures in the sky, at war with the sun, sometimes obscuring its light, demons to be overcome. The connections of the sun to resurrection are eternal and can be observed in our own time at the popular annual sunrise Easter service on Stone Mountain or at other memorial ceremonies there. In connections of the sun to resurrection there is an age-old conflict between light and darkness, life and death, good and evil. It is universal in mythologies that the sun never loses and the light always wins.

Cherokee myths, reflecting older stories, continually addressed nature's rhythms. Sunrise, Indians believed, occurred when Dawn died in the arms of the morning at the Mother of the Mountain, and so the seasons went. Tiny drops of her blood, for example, made autumn leaves red. It was in mystic mountains that the gods prepared for their winter nap, but not until they had composed themselves by smoking a final pipe, in what eventually

came to be known as Indian summer. The gods then slept throughout the cold, dreary winter and did not awake until the renewed sun made the flowers bloom in early spring. After many moons, generations still praise the seasons at Stone Mountain.

Indian Archaeology at Stone Mountain

There is evidence that some time about 9000 BC, Indians visited the area around Stone Mountain. They hunted and gathered food and told stories, perhaps relating them by singing and dancing. Archaeologists at Stone Mountain Park in 1962, excavating during construction of a nearly six-hundred-acre lake, exposed artifacts—several small quartz blades—situated at the base of a hill along Stone Mountain Creek. Subsequently, a two-thousand-square-feet area also yielded a few fire-cracked rocks and artifacts from later eras but no evidence, such as grinding stones and larger tools, to suggest plant cultivation or long-term settlement. Archaeologists believed that the Stone Mountain site functioned as a seasonal short-term hunting camp used by foraging groups. Indeed, the forests throughout the Southeast offered excellent deer and turkey hunting. Open air, quite small and transient, the evidence of such camps is ephemeral, for in a sense Indian hunters were the first "tourists" at Stone Mountain. It remains today a popular place to camp.

As southeastern Indian culture began to build prominent stone mounds, walls and formations in the Woodland period about the time of the first century BC, some structures appeared in Georgia. Stone Mountain for centuries had such a wall. In antebellum times, Reverend F.G. Goulding recalled a visit to the mountaintop that he made with his father and an Indian guide named Kanooka. "Encircling the summit, at a distance nearly a quarter mile from the center," Goulding wrote, "was a remarkable wall about breast high, built of fragmentary stone…But when created and by whom, we could not learn." Kanooka said that the Indians knew no more about it than anyone else. The only doorway was so narrow and low that one would have to crawl through it. Speculation for generations was that these mountaintop wall ruins served as defense fortifications. Some archaeologists now question this premise because associated artifacts have never been found and because no source of water is apparent in such mountaintop enclosures, making any defenders vulnerable to those on the outside. The Stone Mountain ancient

Prehistoric Indian "fortification" or ceremonial wall ruin, now destroyed, was once at the Stone Mountain summit. *Courtesy of Georgia Archives, Virtual Vault, RG 50-2-20, mmg15-1497.*

wall ruin lasted until the early 1900s when, ironically, work crews used its stone as—of all things—road filler!

Another widely reported ancient curiosity atop Stone Mountain, said to have been seen by many generations, was called Devil's Crossroads. It consisted of two crevices or fissures in the rock that crossed almost at right angles. Starting as mere cracks, it was said that they reached a width and depth of five feet at their intersection. The fissures were reportedly of different lengths, with the longer extending about four hundred feet. Over the intersection was a flat rock about two hundred feet in diameter. No trace remains because, as the story goes, quarrymen in the area's developing granite industry destroyed the formation—the deep ledge must have been extremely tempting for stonecutters—but when is not entirely clear. Indians may have been the first to quarry Stone Mountain, but if they did, *how* they did is a mystery.

PREHISTORIC STONE MOUNTAIN AS LANDMARK AND CROSSROADS

As Woodland times gave way to the Mississippian period, from AD 1000 to 1500, hunting became secondary in importance to river valley farming and fishing for southeastern Indians. With its granite outcrops and rocky soil, Stone

Etowah in north Georgia, once the capital of vast pre-Columbian Indian empire including Stone Mountain. *Photo by authors.*

Mountain has never been fertile, and it is not situated on a river, so it remained remote. The ever increasing population of Georgia Indians gravitated near the Oconee, Chattahoochee, Ocmulgee, Coosa and Coosawattee Rivers, forming dense chiefdoms in a kind of horseshoe shape that widely skirted the Stone Mountain area. Beans and squash were important, but corn, brought up from Mexico, may have had a religious element. Etowah to the northwest was a cultural hub much as Atlanta is today. The fantastic Etowah archaeological site near Cartersville, Georgia, still bears witness to a vast hegemony that held sway in north and middle Georgia as far east as the Savannah River. Stone Mountain was peripheral but at the same time important, for its landmark appearance made it a natural hub and crossroads location for traveling bands of Native Americans.

INDIAN TRAILS

Indians for their trails used traces made earlier by buffalos, which once roamed Georgia. In seasonal migrations and travels between feeding grounds and salt licks, buffalos invariably followed lines of least topographical resistance, following watersheds through mountain gaps and along watercourses.

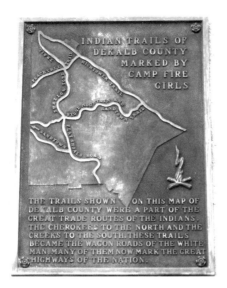

Plaque prepared by Camp Fire Girls and presented to DeKalb History Center depicting prehistoric Indian trails in the Stone Mountain area. *Photo by authors.*

Laying out the most advantageous routes, they beat out paths through undergrowths and vines, leaving trails remarkably free from obstruction.

The main connecting route was Hightower Trail, a major forest path for the deerskin trade that went from Etowah, the most significant Mississippian site in Georgia, to chiefdoms on the Savannah River near present-day Augusta, Georgia. Hightower (the name may have come from Etowah) was a kind of "interstate" highway. The Indian trails followed the higher ridges—natural highways—in order to avoid steep hills and mud flats. In metropolitan Atlanta, remnants of Hightower Trail still serve as a boundary between DeKalb and Gwinnett Counties. The old trail approached Stone Mountain on a ridge where the park golf course is today.

Indians came to call the landmark they visited "Rock Mountain," a more correct name than "Stone Mountain" as stones are only pieces of rock. Rock Mountain became a way station and a vital geographical point of reference in the advanced Indian empire centered at Etowah. Rock Mountain offered a tremendous vantage point to conduct the Indian trade and thus could serve as a lookout and a watchtower, as smoke and fire atop the promontory could be seen for miles. Leading up and down the western slope today, there is a Walk-up Trail most likely following an earlier Indian path to the summit. Native Americans, like the buffalo, always seemed to find the most sensible route.

On the eastern side of the mountain there was, according to accounts of local white farmers in the 1930s, an overgrown racetrack that once had been pounded with mauls to make it hard and smooth. Here they said that Indians had horse races and footraces and played their beloved ball games. Rock Mountain was probably a place for rest and recreation and to meet people from other chiefdoms before resuming one's journey. The Hightower hub location of Rock Mountain led to another trading path, later termed the Stone Mountain–Sandtown Trail, leading west to where the Decatur county

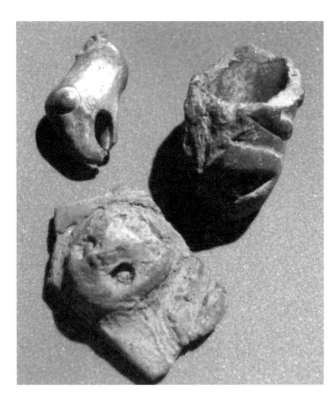

Carved turtle head and other Indian artifacts from Stone Mountain area. *Elias Nour Collection, courtesy of George D.N. Coletti. Photo by authors.*

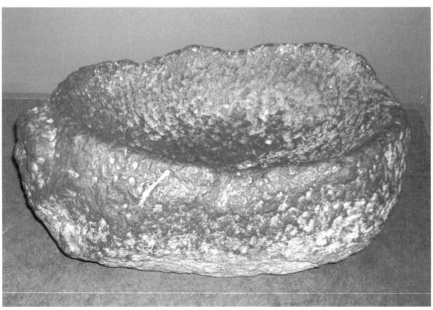

Soapstone bowl, an Indian artifact from Stone Mountain area at Memorial Hall Museum, Stone Mountain Park. *Photo by authors.*

seat for DeKalb County is today. From there, the old Shallowford Trail went to points north. These three great Indian trails in what is now metropolitan Atlanta formed a triangle, giving remote Rock Mountain an emerging central location; however, because Indians in the area were constantly in transit, there was no construction like at the Etowah mounds. All that remains are some artifacts, mainly soapstone, remnants of Indian trails, as well as Stone Mountain itself and, always, the sun.

The harmony of southeastern American Indian culture uniquely thrived at Rock Mountain during its Etowah period. There was no way that people could realize the cataclysmic effects to follow the explorations of Christopher Columbus in 1492. When people traveled, they could see the cosmic, venerated rock of ages about which they had heard so much and that had existed in the old days, when the animals and plants could talk. To those steeped in history, the Stone Mountain we see today still has the spirit of Indians who inhabited it in ancient times. In our new millennium, native tribes gather at Stone Mountain Park in the autumn for an annual powwow. Indeed, today the primal mountain is available for everyone to enjoy. What the Athens, Georgia musical rock group R.E.M. sang in "Cuyahoga" about Ohio applies not only to Indians there but also to those at Stone Mountain. Today's visitors may take heed: "This is where they walked. This is where they swam. Take a picture here. Take a souvenir."

Kenneth Doyle photographs "roadside wilderness," Stone Mountain Park. *Photo by authors.*

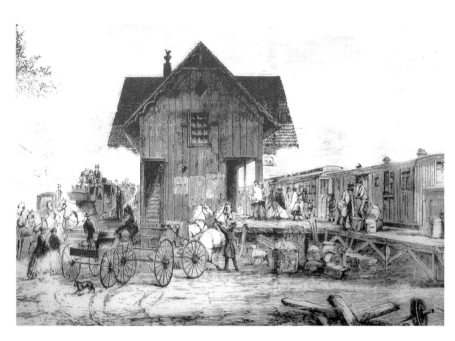

City of Stone Mountain frontier railroad depot. Black-and-white engraving at Memorial Hall Museum. *Courtesy of Stone Mountain Memorial Association. Photo of engraving by George D.N. Coletti.*

From Creek-Muskogee Removal to Railroad Frontier and the Civil War

The collision of Native American and European cultures, called by modern historians the Columbian Exchange, did not occur at remote, transiently populated Rock Mountain. Spaniards did not travel there because it had no gold. However, they considered all land in the Piedmont south of the English Carolinas as territory of the king of Spain. Beginning in the 1560s, Spanish friars established missions along the south Atlantic coast, seeking converts and slaves. Meanwhile, the Mississippian tradition of urban populated chiefdoms persisted inland. Indians lived in sizable river towns of sometimes a thousand, protected by wooden palisades.

Although some local legends say that Spanish explorer Hernando de Soto visited Stone Mountain, he did not. Leaving Florida, he plundered prospering Indian towns from 1539 to 1543 on the Ocmulgee, Oconee and Coosa Rivers, among other places. Like notorious conquistador Francisco Pizarro, under whom he had served in Peru, De Soto took hostages in collars and chains and did not hesitate to kill anyone. He routinely commandeered anything that his slaves could haul away from ransacked Indian granaries. The cavalcade of De Soto, in which cows and herds of pigs brought up the rear, left diseases and misery wherever it went, decimating Indians in its wake from 1539 to 1543. It has also been said that Captain Juan Pardo about 1566 visited Stone Mountain. However, when Pardo saw a great mass of rocks shimmering in the summer heat, called Crystal Mountain by Indians, he was most likely in the area that is now North Carolina.

ROCK MOUNTAIN AS CREEK-MUSKOGEE TERRITORY

As chiefdoms collapsed and large percentages of southeastern Indians died from epidemics, survivors formed a new polity to foster protection. Englishmen from South Carolina about 1715 had named them Creeks because they inhabited river valleys. Culturally the southeastern Indians were connected by a variety of Muskogee languages. Known as the Creek Confederation, it defended Native American claims to all frontier land west of the Ocmulgee River and bounded to the south by Spanish Florida. Rock Mountain remained in Creek-Muskogee territory.

With the founding of Georgia and the settlement of Savannah in 1733, James Oglethorpe established a firm friendship with Tomochichi, chief of the Yamacraws, a band of Creeks. Trade thrived, especially in deerskins, which were used for clothes, gloves and bookbinding. There were upper and lower paths that went through the Creek western backcountry from Coosa and Coweta towns—near today's Rome and Newnan, Georgia—to colonial Augusta on the Carolina frontier, also founded by Oglethorpe. He traveled those routes, but no surviving record of his mentions Rock Mountain. Oglethorpe secured his relatively small coastal colony from Spanish attack, and after the Revolutionary War and independence, restive Georgia disputed boundaries with the Creeks. Indians no longer had the protection of erstwhile

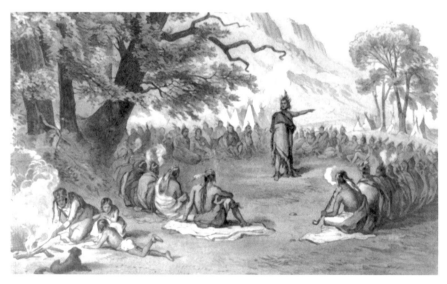

Indian councils throughout the Americas spread word of European intrusion, from which Stone Mountain was for centuries isolated. *Courtesy of Library of Congress.*

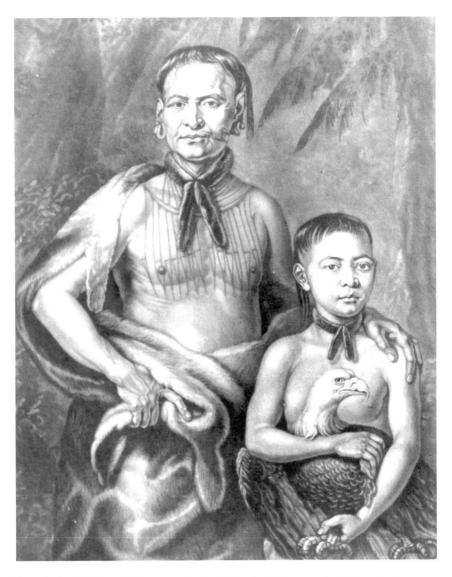

Tomochichi (left), Creek-Muscogee chief (and friend of Georgia colonial founder James Oglethorpe), and nephew have features of Native Americans who traveled near Stone Mountain crossroads. *Courtesy of Georgia Historical Society.*

ally Britain, which had reserved land for Creeks west of the Ocmulgee and south of the Altamaha Rivers. Not very far from Rock Mountain, the fertile Oconee River Valley beckoned Georgians to settle.

President George Washington, knowing that Georgians were determined to migrate beyond what was then their western frontier, dispatched his

friend, Colonel Marinus Willet, from New York in 1790 to meet with the Creeks. All agreed that Rock Mountain, tantamount to an "address," would be the rendezvous. Using another name for the landmark, Willet recorded: "June 9, at 9 o'clock a.m. arrived at Stoney Mountain." Ascending the summit, Willet described "one solid rock of a circular form, about one mile across." He noted, "Many strange tales are told by the Indians of this Mountain," observing that they appeared "very happy." It would not last much longer. Willett and eleven Indian leaders camped at a creek eight miles northeast of Stone Mountain. That afternoon, they commenced events leading to the final loss of Creek ancestral lands in a bitter fruit of the Columbian Exchange.

Assuming leadership for the Creeks at Rock Mountain was Alexander McGillivray, thirty-one, son of a Scottish trader and an Indian woman who reared him in the powerful Wind Clan in the Creek backcountry. His education in Charleston, South Carolina, provided a solid grasp of European history, political science and diplomacy, and he wrote with a facile pen. Like nearly all Creeks, he was a Loyalist and learned much

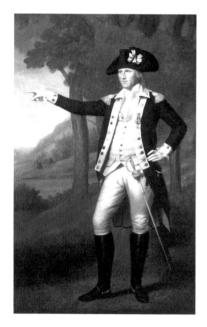

in the British Indian Service in the Revolutionary War. Unlike his father, Lachlan, he stayed in America afterward, becoming an influential Indian leader. His dream was to transform the fragile Creek Confederation into a genuine national power while maintaining Indian traditions. Skillfully playing the United States against Spain, which held Florida, McGillivray had for nearly ten years negotiated tough bargains, so Georgia remained his implacable foe.

Soon after the pivotal Rock Mountain meeting and at President Washington's behest, McGillivray led a Creek delegation to New York and then to the United States capital to meet with Secretary of War Henry Knox. McGillivray signed a treaty of cession for the hunting grounds of Oconee lands, which went to Georgia. In a side agreement, he also accepted

U.S. colonel Marinus Willett began negotiations at Stone Mountain to transfer Creek-Muscogee lands to the State of Georgia. *Courtesy of Metropolitan Museum of Art.*

a commission as a United States brigadier general. The Treaty of New York (1790) ended Indian efforts to transform the Creek Confederation into a sovereign nation. It was also the first treaty between the United States and Native Americans not ratified in Indian-held lands. Alexander McGillivray, who lived much of his short life of thirty-four years as a forceful leader of the Creeks, died in Pensacola in 1793, regarded as a villain by his own people.

Rock Mountain remained in nominally Creek-Muskogee territory through the early 1800s, but its Indian days were numbered. A Creek land cession of 1821 opened to pioneer settlement the area that would eventually become metropolitan Atlanta, and the 1825 Treaty of Indian Springs finally ceded all Creek Georgia land. Reflecting land surveys underway, Adiel Sherwood in the *Gazetteer of Georgia for 1827* noted: "Rock Mt., a high solitary peak…7 m. E. of the Chattahoochee r. It is 2226 feet above the creek that winds at its base and about 7 m. in circumference."

ROCK MOUNTAIN AND GEORGIA SETTLEMENT

English tradition in North America created self-sustaining settlements. English, Scots and Scotch-Irish (Irish Protestants from Ulster province) displaced indigenous inhabitants while systematically expropriating their land. Pioneers—who considered Indians "savages" lacking true property title because of presumed failures to make capital improvements—seized frontier lands for a new pattern of settlement. Rock Mountain and its environs serve as examples.

After the Creek land cession of 1821, Georgia created five extremely large counties, methodically dividing them by survey into land districts, subdivided into land lots comprising squares of 202.5 acres each. This organization, based on English models, is apparent on old state maps. Rock Mountain was so large that it stood partly in seven different land lots in the Eighteenth District of newly created Henry County, named after patriot Patrick Henry. Within a year, in 1822, Georgia divided Henry, creating DeKalb County to facilitate settlement. Rock Mountain remained in the eighteenth land district but in DeKalb, where it has been ever since.

The seat of the new DeKalb County (named after Revolutionary War hero Johan DeKalb) became the town of Decatur. Honoring Stephen Decatur, a

naval commander in the War of 1812, the county seat commemorated a new generation of heroes. Located about seven miles west of Rock Mountain on the old trail conducting trade to Indian Sandtown, Decatur boasted a town square with a frontier post office in a log cabin courthouse. One of its prime functions was to record anticipated new land transactions in DeKalb County.

The old Indian trail from Decatur to Rock Mountain became a wagon road, leading to a small, unorganized pioneer settlement at the base of the rock. After primitive stagecoaches began in Georgia, a route in the 1820s went from state capital Milledgeville through a crossroads at Rock Mountain to Lawrenceville, county seat of neighboring Gwinnett. Other routes followed, carrying mail as well as passengers. By 1834, there was a post office designated Rock Mountain. In 1836, under Postmaster William Meador, Rock Mountain assumed a new official name used by Georgia settlers: Stone Mountain.

STONE MOUNTAIN ON THE GEORGIA FRONTIER

In 1820, Georgia's population of about 189,000 whites and 151,000 blacks had increased 35 percent in only a decade. After America drove Creek Indians west, only Cherokees in mountains north of the Chattahoochee River remained. Pioneers desired expansion in the Piedmont, facilitated by state lotteries that sold old Native American land for a pittance, less than seven cents per acre. By the 1830s, under President Andrew Jackson, a new era in democracy began for men mainly of vague British heritage and born in the United States, emerging as American frontiersmen "free, white and 21." Americans everywhere sought "elbow room," searching new lives in the wild expanse of their country. Only one settlement lay in the shadow of a huge primeval rock more than eight hundred feet high, and so Stone Mountain became both typical and unique.

According to historian David Freeman, the earliest known resident at the mountain was Augustine Young, who stayed on a small hill on the steep side from 1822 to 1833. Frontier stories at Stone Mountain survive today, but there are admittedly no written records. Relatives of early settler John Beauchamp, for example, noted that he traded Indians a musket and a jackass for all of Stone Mountain. As late as 1970, the legendary rifle was the property of Mrs. E.D. Jordan in town. Another story: when a man named Thompson offered to trade his share of the mountain for a silk handkerchief

and a shotgun, Jesse Lanford declined. His shotgun was his livelihood, Lanford reasoned—and a gentleman needed a silk handkerchief! There is a strange truth in these tall tales: Stone Mountain at first appeared practically useless, yet pioneers were drawn to the great big rock.

The term "tourism," meaning recreational travels or tours, had emerged by the early 1800s, and the mountain in DeKalb County was literally a natural. By 1828, visitors celebrated the Fourth of July with mountaintop picnics. The *Macon Telegraph* for April 3, 1830, would have tempted any adventure traveler: "Stone Mountain…three thousand feet in height [*sic*] has the appearance of a large dark cloud streaked with thunder and lightning." Highly recommended was a site of scrub cedars about halfway up, known as Buzzards Roost from the number of birds that flocked there. The summit presented a "beautiful and extensive view of the country." On mountaintop east, there was a little grove called Eagle's Nest, and nearby were "a number of frightful caverns called the Lion's Den, the Panther's Hole, etc." The prehistoric Indian wall ruin offered a man-made curiosity.

The first entrepreneur to build a tourist attraction at Stone Mountain was Aaron Cloud of McDonough, Georgia, who in 1838 spent $5,000 to erect an octagonal "observatory." *Georgia Illustrated* in 1842 described Cloud's Tower as "resembling…a lighthouse…built entirely of wood." There literally was no foundation: "It stands upon the rock with no fastenings and its height

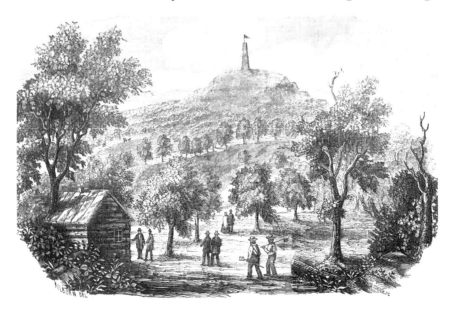

The old Indian name of Rock Mountain briefly persisted in the frontier era as the area became a tourist attraction with Aaron Cloud's tower. *Courtesy of DeKalb History Center.*

is 165 feet." Not surprisingly, Cloud's eccentric tower later blew down in a storm, but it was the first structure to mark in idyllic image Stone Mountain as a tourist destination.

Aaron Cloud had purchased Stone Mountain summit property from Andrew Johnson, a founder of the local village. When Andrew and Eliza Johnson headed inland from South Carolina and arrived at Stone Mountain about 1830, they were not part of an older generation that conquered or converted. Rather they sought to create a family pioneer community. As a wealthy planter, Johnson bought cheap land, establishing on the north mountain end a 2,300-acre cotton plantation, with twelve enslaved blacks. He also acquired lots on the western side, where residents purchased land from him. In 1839, Johnson led a group of men petitioning the Georgia legislature to incorporate an upstart town, where he served as commissioner and postmaster. Its name, New Gibraltar, commemorated an Old World rugged rock. The town later would be transformed by a railroad.

COMING OF THE GEORGIA RAILROAD

The Georgia Railroad began in the Savannah River port of Augusta in 1835 to connect seacoast and hinterland. Its destination was the Western and Atlantic Railroad surveyor's stake Zero Mile Post, where Atlanta began. Located about 6 miles from the Chattahoochee River, 16 miles from Stone Mountain and 170 miles from Augusta, it was unprepossessing. Zero Mile Post was situated on an intersection of Indian trails on high ridges, including Peachtree Road. Starting at Hog Mountain in Gwinnett County, Peachtree went through DeKalb past Standing Peachtree (perhaps "pitch" or pine tree) at the confluence of the Chattahoochee and Peachtree Creek, an old Cherokee village. By 1837, locals called Zero Mile Post, unofficially, "Terminus." It was the "end of the line" for the state-owned Western and Atlantic Railroad, connecting Chattanooga along old Cherokee trade routes. Georgia Railroad planned to connect with the W&A at Terminus, as did the Macon and Western, binding the state's northern interior with east and south. In 1843, Georgia officially named the railroad gulch Marthasville, for Governor Joseph Lumpkin's daughter.

Hastily building frontier railroads, Americans everywhere used shortcuts such as single-tracks (with sidings for passing), cheap ways of laying track and

flimsy wooden trestles. Giving birth to the national expression "railroaded," construction was fast while making paths for settlement. Georgia Railroad construction expanded west to Cumming, Athens, Madison and Covington. In Covington, Joseph Anderson directed his enslaved field hands to lay tracks across plantation property between the Alcovy and Yellow Rivers, and in 1843 planter William Conyers deeded land to the railroad, which named a town for him. Reaching DeKalb County, Lithonia ("town of stone") in granite country was the next stop.

In 1845, the Georgia Railroad, curving twenty miles off a straight course, came through a slightly relocated center for New Gibraltar. Parallel iron girders stretching from east to west, over new roadbeds of rowed wooden ties, elevated the little town's prestige. The first train depot there was a modest wooden frame building, but it symbolized progress and ensured prosperity. Decatur was the next stop east. In 1845, when the Georgia Railroad arrived at its destination, it brought a new name and optimism for the burgeoning little settlement proudly calling itself Atlanta—the "feminine of Atlantic"—derived from the W&A. Old Marthasville sounded provincial and ill fit printed train schedules.

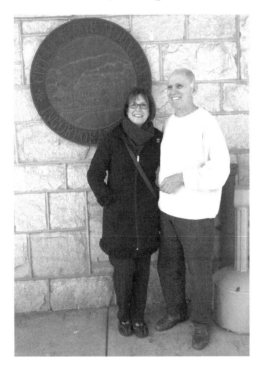

"Mr. and Mrs. Stone Mountain": George and Susan Coletti—he is hometown historian and she is councilwoman—at city hall. The granite structure built about 1918 was a train station on the site of the frontier rail depot. *Photo by authors.*

It was not uncommon for frontier towns to change their names. In 1847, citizens rechristened New Gibraltar, the town beside the mountain, as City of Stone Mountain. The heavily traveled "local" stops on Georgia Railroad schedules described an arc: Stone Mountain, Decatur and Atlanta, connecting to Marietta. Indeed, progress was visible from Cloud's Tower atop Stone Mountain. "Among the towns," William Richards recorded in *Georgia Illustrated* in 1847, was "Atlanta, then a few struggling huts, beyond Decatur."

Atlanta was thriving as a train hub by the 1850s, and Stone Mountain prospered on the periphery as a one-railroad town. Passenger cars were often packed full in ways that shocked Europeans. Accustomed to first-, second- and third-class compartments, they also piled into open cars willy-nilly. Rich, poor, educated, ignorant, polite and vulgar were elbow to elbow. White masters, enslaved blacks, friends, family and strangers practically sat and slept on one another in close quarters. Smells were everywhere: sweat, perfume, salt, tar, fish, molasses and, always, nicotine smoke. Men spit tobacco, and women spit lemon and apple seeds. When the conductor exclaimed, "Stone Mountain, fifteen minutes!" everyone poured onto the station platform to "lunch counters," buying hardboiled eggs, ham, pies and custards while glancing at the looming mountain, devouring their "quick lunch" and continuing their journey upon the sounding bell and urgent call "All aboard!"

For travelers wishing to tour Stone Mountain, hotels owned by local entrepreneurs Aaron Cloud and Andrew Johnson offered lodging. Hotels in frontier towns assumed the stature of civic buildings and a public face, symbols of how the community thrived and lived. Meals of fresh local vegetables, included in "room and board," created a homey atmosphere for hotel guests. The village grew in typical rail town style, with streets parallel to the train tracks in a grid pattern visible today.

By the eve of the Civil War, the *Georgia Gazetteer* recorded 164 white family households at Stone Mountain, in the village and outlying areas, as well as

A nostalgic view of the Stone Mountain antebellum depot by Atlanta artist Wilbur G. Kurtz, rendered at the time of Civil War centennial, circa 1961. *Courtesy of DeKalb History Center.*

290 enslaved blacks. Most African Americans lived on ramshackle farms outside the village. About forty town homes had enslaved domestics, usually one per household. Nearly all buildings at Stone Mountain were the classic frontier-style "balloon-frame": light frames of two-by-fours held together by nails. The few blacks per farm lived in tiny cabins or in houses with their masters. Often, all plowed together while hearing trains whistling the sounds of American progress. By 1857, Stone Mountain boasted a new railroad depot with partial granite walls quarried from a local ledge.

As the great national issue of secession loomed, many citizens in Stone Mountain, DeKalb County and north Georgia, where there were few large plantations, initially supported the Union, but in 1861 the majority cast their lot with the Confederacy. Stone Mountain's location on the vital Georgia Railroad and proximity to Atlanta eventually drew it into strategies in the Civil War.

Early Civil War and Atlanta–Stone Mountain Homefront

Fighting did not at first take place in the Deep South, sparing Atlanta and environs, including Stone Mountain. Starting in March 1863, Lemuel Grant, a native of Maine and chief engineer of the Georgia Railroad, took charge of fortifying Atlanta. (Later he deeded his land to the city, and it became Grant Park.) Grant used enslaved labor for construction of trenches and long sections of spiked stakes called *chiveaux-de-friese* that protected Confederate breastworks, making them nearly invulnerable to frontal attack. Troops and supplies came daily by rail through Stone Mountain on the way to Atlanta as it became fortified second only to the Confederate capital at Richmond. The Confederacy celebrated early victories at Fort Sumter and Manassas but, by July 1863, had suffered a crushing defeat at Vicksburg.

One of the best surviving chronicles of wartime Atlanta, the Samuel Richards Diary, relates how he took his family on a picnic to Stone Mountain to assuage their grief over Vicksburg. Richards, an Englishman and Confederate patriot, had paid a substitute to meet his military service while he operated a successful bookstore in Atlanta. Sam, his wife Sallie, his daughter Dora, her aunts Martha and Harriet and uncle Jabey, along with the enslaved Ellen—rented to "carry our dinner," as Sam wrote—left Atlanta at 7:00 a.m. on July 21, 1863.

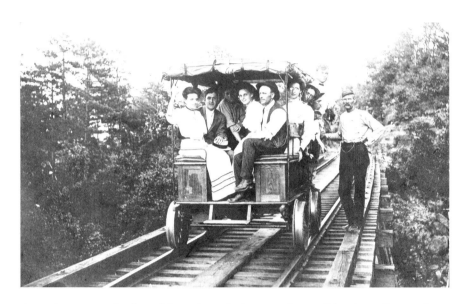

A creative way to enjoy Stone Mountain: a picnic party takes a rail handcart. *Courtesy of Georgia Archives, Vanishing Georgia, dek178-85.*

Taking the sixteen-mile trip by Georgia Railroad to Stone Mountain, by 9:00 a.m. the Richards party had ascended the mountain. The "refreshment saloon" halfway up was closed, and the summit tower was but a pile of lumber and stones, "wrecks of the past," Sam noted. They took lunch at 11:00 a.m. with only peaches and apples for their thirst. Descending the mountain, they drank two pails of water at a hotel, which did not charge "if people *behaved* themselves." Riding the crowded train back to Atlanta, the men had to stand. It was a pleasant day, but within a year everything would change with the dreaded Union attack on Atlanta, which had actually prospered, with twenty thousand residents.

STONE MOUNTAIN AND CIVIL WAR

The majority of young white men at Stone Mountain volunteered for Confederate service, joining Wright's Legion, Thirty-eighth Georgia Regiment Volunteer Cavalry. Local artillery battalions used the mountain as a firing range to test breech-loading cannons forged in Atlanta. Meanwhile, the battle-toughened Union army consolidated its successes while implementing

the Anaconda Policy to squeeze life out of the Confederacy. President Abraham Lincoln had changed strategic objectives with his Emancipation Proclamation, establishing a war for freedom.

General William Tecumseh Sherman, Union commander of the Atlanta Campaign, had ruled out a frontal assault on the city, which he desired as the "turntable of the Confederacy," a critical railroad center. Sherman planned to flank around Atlanta and cut all railroad arteries, making Stone Mountain not only a military target but also a jumping-off place on one approach to Atlanta. On Civil War maps of the Atlanta

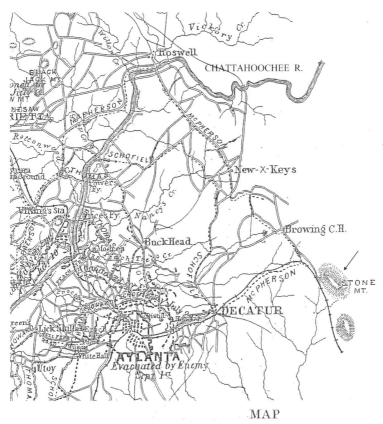

MAP

Showing the operations of the national forces
under the Command of
MAJ. GEN. W. T. SHERMAN
During the Campaign resulting in the capture of
ATLANTA
GEORGIA
Sept. 1, 1864.

Vintage Civil War map of the Atlanta campaign, amended to show Stone Mountain on the eastern periphery of the war theater. *Courtesy of Carrie Jacobs Henderson. Image detail by Nelson Young.*

49

Campaign, Stone Mountain usually appears as a landmark on the extreme eastern perimeter. Today in Confederate Hall at Stone Mountain Park, there are regular showings of an excellent documentary film narrated by Hal Holbrook on the Atlanta Campaign, entitled *Georgia and the Civil War*, detailing General Sherman's strategy.

Sherman charged Major General James B. McPherson to swing wide to the southeast and strike the Georgia Railroad leading to Decatur before he moved to Atlanta (where McPherson was destined to die). Near McPherson was the division of Union brigadier general Kennar Garrard of the Army of the Cumberland Second Cavalry Division; he had crossed the Chattahoochee near Roswell, which he occupied briefly before going overland into DeKalb

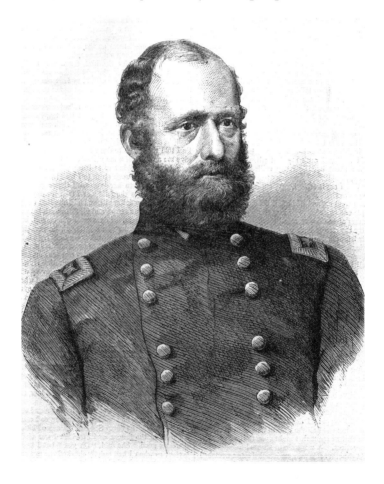

Union general Kennar Garrard's raiders liberated African Americans along the Stone Mountain–Decatur Road. From *Harper's Weekly*, February 11, 1865. *Courtesy of Son of the South.*

County to secure Stone Mountain. Garrard peered at Stone Mountain in a driving rain as he contemplated his marching orders. "I want you to put your whole strength at this," Sherman had written, adding coldly, "it will justify the loss of [a] quarter of your command." Garrard, thirty-six, Harvard-educated scion of a wealthy Cincinnati family and a West Point graduate who had brilliantly defended Little Round Top at Gettysburg, was Sherman's only cavalry commander south of the Chattahoochee. Known by his men as the "Royal Tiger," the dashing Garrard had warrior courage and the love of his men.

Kennar Garrard Leads Stone Mountain Skirmish

Starting on July 15, 1864, Garrard led skirmishes against Rebel cavalrymen at the edge of Stone Mountain Village. After Confederate riflemen under Colonel George G. Dibrell took up deadly sniper positions in town buildings, Union forces brought artillery and drove the Rebels out of town. A fine watercolor painting rendered about 1960 by Atlanta artist and historian Wilbur Kurtz, on display at the Memorial Hall Museum at Stone Mountain Park, depicts Dibrell's troops before their retreat. Upon leaving, they burnt more than two hundred cotton bales so that Federal forces could not get them.

Writing to General McPherson on July 18, 1864, Garrard reported, "I left my camp at 5:00 a.m. to break the railroad between Stone Mountain and Decatur." Confederate resistance appeared minimal. "The only force I had opposed to me, as well as I can learn, was one brigade," noted Garrard, who led five regiments with several thousand men. "I sent a force into Stone Mountain and found the rebels there about 5:00 p.m. but not in force," Garrard related, adding that "The depot was not burned." While the skirmish at Stone Mountain, about a mile north of the village on the Decatur Road, was not a major engagement, it cleared the way for Union destruction of the vital Georgia Railroad supplying Atlanta. "I struck the rebel pickets and skirmished for three miles to the railroad," Garrard wrote to McPherson.

The real destruction by Garrard began about a mile from the 1857 Stone Mountain train depot, which no longer stands. In the period of July 18–22, 1864—about the same time as the pivotal Battle of Peachtree Creek—Kennar

Garrard and his raiders wreaked havoc along the Georgia Railroad from Stone Mountain to Decatur. "We diligently went to work to destroy the road, tearing up the track, building fires," Private John Puck wrote, "twisting the rails around small saplings." Burning rail depots—Covington went up in a blaze nearly one hundred feet high—as well as strings of flatcars and storehouses of cotton, they made free with horses and mules and emptied smokehouses while ransacking plantations of syrup, meal and flour, gleefully taking tobacco. The raiders accomplished their strategic mission, destroying the Georgia Railroad bridges over the Yellow and Alcovy Rivers. Garrard was so successful that he had only five casualties total.

The raiders of Kenner Garrard captured about 175 prisoners, but his was not the usual Georgia campaign. When they camped and cooked those nights after leaving Stone Mountain, Union soldiers noticed increasing numbers of newly freed men and women peering at them through the eerie, dancing shadows. Moved by pity, many soldiers shared the food they had ransacked. Reaching Decatur on July 22, Union soldiers had in tow more than 100 newly freed blacks, liberated but owning nothing. Ironically, they had first seen the dawn of freedom in the light of the night fires on the Stone Mountain–Decatur Road.

"The Whole Horizon Was Lurid with the Bonfires of Rail Ties"

Meanwhile, methodically destroying all railroads connecting Atlanta, General Sherman literally cut the city off from the world, laid siege to it with his big guns and won the epic Battle of July 22, as it is locally known. The Cyclorama building in Atlanta holds a huge nineteenth-century painting of a wide panoramic sweep of the 1864 battle, a Civil War turning point that ensured Lincoln's reelection. Kennesaw Mountain and Stone Mountain serve as landmark perspectives in the distance.

On November 15, 1864, Sherman left Atlanta as a military headquarters. Looking at the ashes, one Union soldier wrote that "there was nothing but ruin, as far as the eye could see." Leaving the destruction behind, Sherman's troops, with liberated black refugees in the rear, camped at Lithonia. The victorious general gazed thoughtfully at Stone Mountain ahead in the distance. It alone was substantially unchanged, standing as

This Stone Mountain rail depot was built in 1857 and burned down during the Civil War. *Courtesy of DeKalb History Center.*

novelist and town historian George Coletti in 2010 termed "the Granite Sentinel." Sherman in his memoirs vividly remembered that "Stone Mountain…was in plain view, cut out in clear outline against the blue sky; the whole horizon was lurid with the bonfires of rail ties." Never had the Georgia landscape dominated by the great mountain seemed so forlorn and desolate.

As Sherman reviewed plans for his "March to the Sea," he could not see Stone Mountain Village, where damage was nowhere as great as at Atlanta. However, he dispatched troops on his left wing to return to the Stone Mountain vicinity, where they camped on November 16, 1864. According to town legend, freed African Americans named their neighborhood Shermantown in honor of the night the liberator's troops spent at Stone Mountain. The next day, the Second Massachusetts Volunteer Infantry, acting as Sherman's rear guard, burned public property, including the Stone Mountain depot. Its wooden parts, including the roof and platform, were in ashes. (However, the thick granite walls, impervious to fire, still stand as part of the 1918 granite depot that presently serves as Stone Mountain City Hall. The two-foot-thick stone walls that withstood the flames of the Civil War are on the southern side of the archway.)

Some local liberated blacks chose to follow General Sherman on his march through Georgia, but many stayed at the village of Stone Mountain, for it was home. The town had torn up railroad tracks and burned cotton storehouses and other structures, most importantly the water tower. Everyone knew that buildings could be reconstructed, and that meant jobs and working together. But establishing a true community from that point forward involved a historic milestone for which no one was prepared: emancipation.

DR. HAMILTON HOUSE (OLD SYCAMORE GRILL BUILDING), 5329 MIMOSA DRIVE, STONE MOUNTAIN, GEORGIA

Constructed as a home in 1836 by city father Andrew Johnson, this building—in recent times locally identified by the towering 150-year-old sycamore tree on its eastern side—is a signature structure of Stone Mountain Village, particularly illustrating its history from antebellum times through the Civil War. Johnson built the house adjacent to the route subsequently chosen for the Georgia Railroad and later removed a portion of the building to safely allow the passage of trains. The original construction of plantation plain architecture with a shed porch was one floor and unusually solid, with two-foot-thick brick walls made of horsehair, mud and granite aggregate.

In 1840, the Georgia Railroad and Banking Company added the clapboard second-floor addition, also with a matching porch, and the building became a hotel for railroad workers. It was the center of the upstart town of New Gibraltar, and in 1843 the Georgia

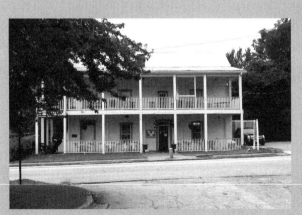

The antebellum Dr. Hamilton House (old Sycamore Grill building), with a rich history, is now the Rock House Grill in Stone Mountain Village. *Photo by authors.*

legislature extended limits six hundred yards from a surveyor's post, which still stands as an icon in front of the building. After the 1847 incorporation of the city of Stone Mountain, the milepost extensions stretched one thousand yards for further growth. During the Civil War, the building was known as the Dr. Hamilton House, serving as a Confederate hospital, crowded sometimes with as many as twenty-six men packed into the upstairs room number two.

General Sherman spared the charming building that later served for more than a decade as the Sycamore Grill. The property, listed on the National Register of Historic Places, became the Rock House Restaurant in 2010. The structure remains adjacent to the railroad, with a fine view of Stone Mountain.

Other Confederate hospitals (they flew yellow flags in the Civil War as a designation) at Stone Mountain include the 1850 clapboard Stillwell House at 992 Ridge Avenue, which is also on the National Register and is now the Village Inn bed-and-breakfast. A third Confederate hospital was the old Wayside Inn. Located at the site of Confederate Hall at today's Stone Mountain Park, the building burned down in 1925.

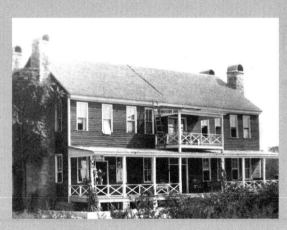

Wayside Inn, no longer standing and once a Civil War hospital, at the present site of Confederate Hall in Stone Mountain Park. *Courtesy of DeKalb History Center.*

After the Civil War, many whites and blacks around Stone Mountain were in classic sharecropping relationships. *Courtesy of DeKalb History Center.*

Stone Mountain in Black and White

After the Civil War, when America was still half explored, the village of Stone Mountain began to allow some racial freedom while, for the first time, embracing southern industry. The village at the foot of the great mountain, in effect, became reinvented, venerating the Old South while accepting some northern ways, as did other communities throughout the region as they embarked on America's great experiment in democracy.

CIVIL WAR REMEMBRANCE: STONE MOUNTAIN CITY CEMETERY AND CONFEDERATE SECTION

"Row after row with strict impunity the headstones yield their names," wrote Allen Tate in his immortal 1937 "Ode to the Confederate Dead." The Stone Mountain City Cemetery with its Confederate section, which is on the National Register of Historic Places, presents this indelible image. The graves there tell stories; "Gone but not forgotten" is a frequent plaintive lament. And there is Christian hope: "We trust in God to meet again." The young soldiers from the Stone Mountain Guards, Company H, Eighth Regiment, Georgia State Guards, are in full force, as are the older men who did their part, including a postmaster in the Confederate States Postal Service. "Wounded in the Battle of Atlanta" and "Killed at Spotsylvania

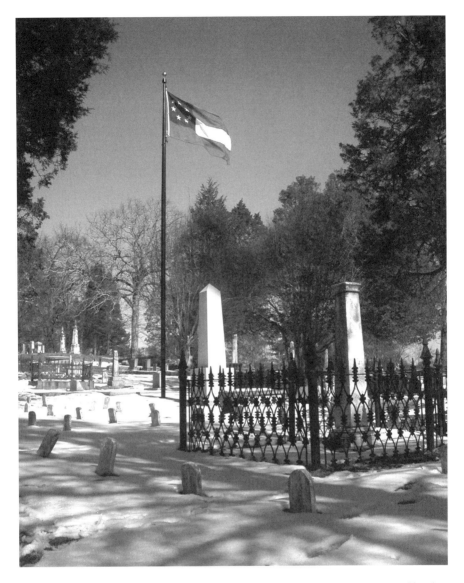

Monument for the unknown Confederate dead at Stone Mountain City Cemetery. *Photo by George D.N. Coletti.*

Court House," the tombstones bear silent witness to the men in gray. There is even gentle southern irony with a grave from a neighboring county company, the marvelously named Gwinnett Beauregards.

Today, at the often busy intersection of North Main Street, East Ponce de Leon Avenue and Silver Hill Road, not far from the West Gate entrance to Stone

58

Mountain Park, Stone Mountain City Cemetery with its old Confederate section is a fine example of traditional public memory of the Civil War. It was Stone Mountain Village's original foray into the Lost Cause, a historical interpretation that sought to present the war from a nostalgic Confederate viewpoint. Women of the village, as a "Ladies Association" (having distinguished themselves as nurses at the three Confederate hospitals in town hotels, which Sherman had ordered to be spared) led the effort to establish a cemetery. The Confederate section of the larger Stone Mountain City Cemetery (which was later expanded to sixteen acres) has a character similar to nearly 150 years ago. The entire complex is open daily from dawn to dusk.

The lovely cemetery is a tidy, sacrosanct haven, providing glimpses of Stone Mountain through the trees, where citizens transformed death and carnage into, in the Victorian sense, a "place of sleep." In front are interred 150 unknown Confederate soldiers who perished in the Battle of Atlanta. While some died from skirmishes, most were victims of infection, illness and diseases such as diarrhea, smallpox and measles. In the typically unsanitary public health conditions of the war, thousands of men died from contaminated water. The *Georgia Narratives* relate that enslaved blacks who worked hospital duty for the Confederate wounded helped remove and bury the dead, and Stone Mountain was likely no exception.

POSTWAR BLACKS AND WHITES AT STONE MOUNTAIN VILLAGE

Confederate heroine Mary Gay, fleeing Decatur for Stone Mountain during the Battle of Atlanta, was struck by the devastation she saw. "Ah, those chimneys standing in the midst of smoldering ruins," she sighed. By 1866, though, Stone Mountain had begun to bounce back. The Georgia Railroad quickly rebuilt the wooden sections of the old train depot, which still had its pre–Civil War granite walls. On October 4, the *Atlanta Intelligencer* advertised the Blue Front—which literally was its distinguishing Victorian feature—as an "Eating House." M.D. Lee & Co. notified the "traveling public on the [Georgia] Railroad or otherwise" of its accommodations, including a "first rate cook and attentive servants." They almost certainly were freed people who had settled in or around the village.

Records are not available for many of Stone Mountain's newly freed people, but a good number stayed in their environs for various reasons. As was the custom in rural areas, paternalistic whites "vouched" for many blacks. Selected opportunities other than farming involved the rebounding tourist trade. While the Georgia Railroad generally prohibited company work for African Americans, it created collateral jobs for them. Hotels and restaurants employed not only cooks but also maids, bootblacks and other general servants.

Skills learned on plantations—including blacksmithing, carpentry, tailoring, shoemaking and cabinetmaking—transferred well to a railroad community starting over. African Americans had long dominated the profession of barbering for blacks and whites, catering to only one or the other. Blacks were also prominent as draymen, or wagon drivers, which sometimes included taking tourists on popular hayrides to the mountain. Peddling—produce, cooked poultry and baked goods—in the area of the train depot was a start for those wanting to be grocers. "In the towns and villages the colored people have a prosperous look; they dress neatly," a Georgia observer noted as thrifty blacks began to form a small middle class.

Places to live for ambitious blacks at Stone Mountain may have developed based on longstanding relationships with whites dating back to enslavement. Sherman's Special Field Order No. 15, the vaunted "40 acres and a mule" arrangement issued in 1865 from Savannah, was experimental and applied largely to rice plantations in South Carolina. The order never became general and usually benefited freedmen from larger plantations. In the closely knit village of Stone Mountain, both formerly enslaved and masters had known and needed one another and perhaps realized the challenges that sudden freedom presented. The 1870 census of Stone Mountain suggests that freed blacks rented homes from whites in a remarkably integrated neighborhood in the southern part of the village. Later called Shermantown, it surfaces on a 1917 city map, by which time the original landowners had relocated. Stone Mountain's tourism meant that postwar blacks could share some of the profits of town life.

The first living spaces for blacks at Stone Mountain were rude, typical cabins having a single door and, for illumination, a square window with a wooden shutter. There rarely was glass or a porch. Sometimes there was a fireplace, black and smoky. There might be a bed or two, a table, a wooden chest and a few chairs. Rural cabins were frequently crowded with extended families, just as in cities. Blacks spent most of their lives outside these depressing dwellings, and nearly everybody worked a contract or regular job.

Postbellum Wells-Brown House, home to local historical society in Stone Mountain Village. *Photo by authors.*

One of the most elegant town homes in Stone Mountain is the Wells-Brown House. Constructed in 1870 by George Riley Wells, a physician in the Confederate army, it is a beautiful white Victorian Greek Revival structure with four Doric columns and a lovely view of the mountain from the second story. In 2005, the new Stone Mountain Historical Society saved the house in severe dishevelment, a recent life-affirming story in the still quaint village.

Both whites and blacks farmed at Stone Mountain, in and outside of town. Crops planted were garden vegetables in April, corn in May, melons in June, sweet potatoes in September and winter produce such as cabbage and beets. Wild blackberries, which still abound at Stone Mountain, were vital for starving whites and blacks in the years after the Civil War. Most ignorant workers of both races who only knew farming turned to sharecropping cotton, entering an endless cycle of debt.

At Stone Mountain as elsewhere in the South, white merchants "furnished" meal, coffee, sugar, clothing, seed, fertilizer and tools for croppers, who in turn commonly executed chattel mortgages on their mules. The currency was cotton, salable for ready money, and so landlords demanded this commodity as rent. Social scientist W.E.B. Du Bois, at Atlanta University in the 1890s,

Echoes of the past: contemporary Shermantown community vegetable garden. *Photo ©
Columbus Brown.*

noted that the only ways for blacks to prosper were to buy land or work in
town. But at Stone Mountain, another alternative emerged for both whites
and blacks after the Civil War: the American granite industry.

Granite had become symbolic in America during the construction
of Boston's Bunker Hill Monument in the early nineteenth century.
Solomon Willard, the first of granite's "self-made men," selected Quincy,
Massachusetts, for the monument's stone. Crucial to the quarry scheme
was the Granite Railway, hauled by horses and using new devices such as
switch and turntable. In seaboard cities, citizens wanted prominent public
structures, such as courthouses and merchant exchanges, built of granite.
A new architectural style used granite for large blocks instead of just lintels
and underpinnings, creating a monumental effect. Granite led to improved
construction of dry docks in Norfolk, Virginia. Mount Auburn Cemetery
in Cambridge, Massachusetts, America's first Victorian "garden cemetery,"
created more demand for Quincy granite monuments. As cities outgrew dirt
roads, they needed granite paving blocks. Granite's importance for building
America reached out to Stone Mountain, and the town responded in New
South ways, emulating northern commercial success.

NEW STONE AGE AT THE MOUNTAIN

The 1850 census at Stone Mountain listed ten independent quarrymen, mainly white, who cut rock from loose boulders, hand drilling holes and hammering wooden wedges in. Next the men poured in water to swell the wedges, expanding the granite for splitting. About this time, Andrew Johnson sold his extensive landholdings, and after a series of deals, the new Stone Mountain Granite Company in 1869 purchased the entire property for $45,400. Included were rights to build soon afterward a Georgia Railroad spur line connecting the town with the quarries. Nicknamed the "Dinky train" because it was smallish and ran on narrow-gauge track, it was the quarrymen's commute. By then, compressed-air tools made rock drilling no longer an explicitly manual task.

Various mergers led, in 1878, to the Stone Mountain Granite and Railroad Company. Its first skilled stonecutters were English, Welsh, Scots, Swedes, Norwegians and Italians, boarding in the village. Their rowdy behavior and drinking caused local churches—Southern Baptist, Methodist and Presbyterian—to protest vigorously. Soon, sober local blacks and whites learned jobs in the quarries. These workers, dusted with "white gold" granite grit and aching after a day's work, became fixtures in the village. When their wives boiled work clothes, the metal tubs collected sandy water the

Vintage postcard of Stone Mountain Granite Company when area quarry industry prospered. *George D.N. Coletti Collection.*

color of skim milk, but there was money, pride and brotherhood for all men dedicated to the new stone trade.

Meanwhile, quarrymen discovered how to separate long shelves of granite from the mountain by explosives, called "raising a ledge." In 1886, the newly formed Southern Granite Company took over quarry operations at Stone Mountain. Vice-President William Hoyt Venable (1852–1905) and his brother, General Manager Samuel Hoyt Venable (1856–1939), became driving forces to start a great granite industry destined to affect Stone Mountain, Atlanta, the South and the world.

William and Sam, the eldest of eight Venable children, had been boys at Stone Mountain during the Civil War and had become responsible for the family after their father's death in the hard times of 1874. William graduated from Oglethorpe University, which had closed in Milledgeville during the war and, for a time, relocated to downtown Atlanta in the 1870s. Admitted to the Georgia Bar, William understood issues of property involving land law and mergers. Younger brother Sam, more in the "self-made" mold, had failed as a banker and a grocer. He was the first to see the potential of Georgia granite and became legendary.

"Tellers" at the Venable family granite mausoleum at Historic Oakland Cemetery in Atlanta still relate stories of how Sam once saved his young company. Using up its ledge, Sam needed another one for more granite. Yet his working "blockers" wanted paychecks even though, temporarily, there was nothing to quarry. And so Sam invited them over for beer with a sporting offer. "I said I would 'rassle' each of them," Sam declared, and "every man who threw me down would get his full wages of six dollars a day." Whomever Sam threw down, though, would be obliged to wait a week without pay while the boss found more granite. The blockers jumped at the chance because they were bigger than Venable, but he was, as they later said, "wiry." And so manly Sam threw down nine blockers—and after a ten-minute "breather" he threw down ten more! "Nobody else wanted to 'rassle,'" a satisfied Sam said, and "they just agreed to wait." Luckily, Venable quickly found another ledge with more granite. Some southern stories are truer than others, but this one accurately highlights the granite will of Samuel Venable

Unlike in the Northeast, which had billionaires during America's Gilded Age of the late nineteenth century, Atlanta had just a few millionaires, including the two principals of Venable Brothers Contractors, an empire with a vast stock company. They bought Stone Mountain for $48,000 in 1893 to monopolize its quarries. "BIG GRANITE DEAL" screamed the *Atlanta*

Mausoleum of Stone Mountain granite, holding remains of village leader Sam Venable, at Atlanta's historic Oakland Cemetery. *Photo by Ren Davis.*

Constitution on March 14, 1894, when the Venables made critical purchases in nearby Lithonia, controlling "nearly the whole of granite lands in DeKalb County." Material construction and curbing good roads in America was its strongest suit. "There is no such granite for paving purposes such as this," the *Constitution* observed, referring to desired high density and uniform color. "The great demand has caused the Venables to get all the contracts they bid for, and yearly the [quarry] property has increased in value." A new term ("boom") described the economy as it spiked a distinctive phase of America's industrial revolution. Boom was literal at Stone Mountain—every deafening dynamite explosion meant more lucrative granite to build, pave, memorialize and glorify a growing, confident country.

Today's Stone Mountain Park outdoor quarry exhibit, entitled Raising a Ledge and located near the roundabout on Robert E. Lee Boulevard, is one of the park's most impressive historical presentations. There is a polished granite "Honor Roll" wall listing selected sites made from indigenous quarry stone. In addition to numerous Carnegie libraries and courthouses, the sites include the capitols of Georgia (foundation and cornerstone) and the United States (East Wing steps). Other national government structures include the Treasury vaults, gold depositories at Fort Knox, four Federal Reserve Banks, Atlanta Penitentiary, Chickamauga National Battlefield and Arlington Memorial

Bridge. Also made of Stone Mountain granite are the Detroit Tunnel to Canada and the Balboa dry docks of the Panama Canal.

The exhibit, dedicated to the late SMMA designer Jerry Deagan (1940–2003)—a touching inscription notes, "He stretched our imagination"—and brilliantly situated in an old ghost quarry, works extremely well. One passes granite outcrops with smooth rock underfoot to see blown-up vintage photographs of both black and white quarrymen—hammer men, polishers, finishers, laborers and foremen—working together on the slopes and in the sheds. African American blacksmiths expertly sharpened chisels for white stonecutters, as a caste system prevailed. Yet comradeship was there. All men breathed the same debilitating silica dust from the motor saws, while falling blocks created widows equally. There was a grim democracy in the

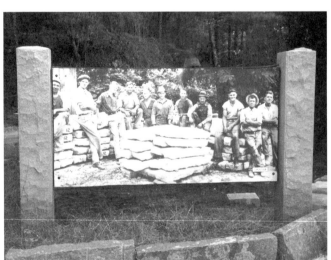

Above: One of many outstanding interpretive brochures at Stone Mountain Park. *Courtesy of Stone Mountain Memorial Association.*

Left: An enlarged outdoor museum photographic display of stoneworkers at the park's quarry exhibit. *Photo by authors.*

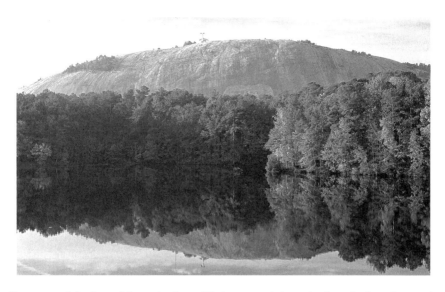

Panorama of the Stone Mountain dome. Workers quarried granite from the late nineteenth century until 1978. *Photo © Larry Winslett.*

persistent dangers of compressed-air tanks, which blew heavy steel lids that killed when they exploded. In 1898, the Granite Cutters National Union chartered the Stone Mountain branch, which eventually led to improved work conditions for the quarrymen.

One gets from the quarry exhibit a sense of monumental granite with an enormous sixty-six-thousand-pound block on display. It could have been cut into 110 standard six-hundred-pound backbreaking blocks that black laborers transported in mule-drawn carts to the train. Today the most instructive time to visit the quarry exhibit is July, in extreme heat, which might be 110 degrees on the rock. Broiling conditions employed more quarrymen to "raise a ledge" that would split straighter. One can envision cutting sheds that employed more than one hundred workers at peak times.

Warning: if stretched imaginations persist while visiting the quarry exhibit, they may continue with the whistles and bells of today's Stone Mountain Scenic Railroad as it chugs around the mountain. The railroad follows part of the spur route of the old Dinky train from about 150 years ago, when Sam Venable employed black and white stoneworkers on the way to his fortune. All of their spirits are, in a sense, living history at the old Stone Mountain Quarry at the park.

Above: Stone Mountain Village, with church, from a vintage postcard. *George D.N. Coletti Collection.*

Below: Bethsaida Baptist Church, the oldest African American church in the Shermantown community at Stone Mountain Village. *Photo by Julie Jarrard.*

Historic neighborhood Shermantown, with Stone Mountain in the distance. *Photo by Jennifer Wilkerson.*

STONE MOUNTAIN AND EARLY SEGREGATION

Through the 1880s, blacks in Georgia enjoyed a measure of freedom, even though their education was "born segregated." Blacks and whites for some years sat together on the Georgia Railroad, and Stone Mountain had integrated shopping. Starting in the 1890s, however, racial discrimination statewide hardened into segregation. The stepchild of enslavement, segregation was a method of social control and denial of political rights, upheld by the Supreme Court ruling of "separate but equal" for the races. Atlanta and Decatur, for example, were rigidly segregated by law.

Historian Mark Schultz, in *The Rural Face of White Supremacy* (2005), contends that rural race relations were marked by personal relationships in what he calls a "culture of localism." It appears that Stone Mountain used custom rather than law to maintain segregation. The town was a world away from Atlanta, which had its awful Race Riot of 1906 in which whites attacked blacks indiscriminately for four days. The riot spread throughout the city and on to Decatur but never reached Stone Mountain. By the early 1900s, blacks at Stone Mountain had retreated to Shermantown—complete with churches,

groceries, recreation spaces and schools—circumscribed within the village. Venable Street in the community offered a spectacular mountain view.

SAMUEL VENABLE AND REVIVAL OF THE KU KLUX KLAN

In 1913, Samuel Venable was realizing his dream of twenty-five years to build in Atlanta a mansion of finest Stone Mountain granite, which he had carefully selected. Named Stonehenge, the $75,000 rock Tudor mansion designed by noted architect Edward Dougherty still stands in Druid Hills at the corner of Ponce de Leon Avenue (a direct drive from Stone Mountain) and Oakdale Drive. Inside is a two-story great hall, a huge staircase, balcony and a gothic fireplace with the Venable coat of arms.

Stonehenge was more house than the bachelor Venable needed, but it emphatically underscored his entrance into the Atlanta white elite at a time when the city was in turmoil. The murder of young Mary Phagan in 1913, allegedly by her Jewish employer Leo Frank, focused attention on the National Pencil Factory building. Originally constructed as the Granite

Samuel Venable's Stonehenge granite mansion on Ponce de Leon Avenue in Atlanta. *Photo by Julie Jarrard.*

Hotel, with stone from the Venable quarries, the family subsequently regained ownership. The structure retained an identity with Venable even after it became a factory. At the widely publicized Leo Frank trial, courtroom diagrams consistently referred to the crime scene as the "Venable Building."

Frank's conviction and subsequent lynching in Marietta, along with the Atlanta debut of D.W. Griffith's film *Birth of a Nation* in 1915, led to the revival of the Ku Klux Klan by "Colonel" William Joseph Simmons. Although he gathered his first initiates at the Piedmont Hotel in Atlanta, he had a surprise: they would take a tour bus to rural Stone Mountain for formal initiations. Although there are no real records of the "secret" society, Venable, a Klan sympathizer or member, obviously gave permission to use his property. Initiates ostensibly meditated on the consecration of ritual responsibilities as their bus motored from Atlanta through Decatur and on to Stone Mountain.

FIERY CROSS ATOP STONE MOUNTAIN

Ascending the more than eight-hundred-foot high summit on Thanksgiving night, November 25, 1915, according to Klan lore, the first members (about fifteen) of the revived KKK solemnly assembled. They stood before a giant pitch- and kerosene-soaked wooden cross kindled by excelsior that Simmons had put in place. "Suddenly I struck a match and lighted the cross," he later recalled. The blustery, surging winds blew on the mountaintop, but the celebrants felt "bathed in the sacred glow of the fiery cross." Perhaps the nearest spectators in the village were black citizens outside their homes at Shermantown, gazing at the stars over the mountain as their Thanksgiving holiday drew to an ironic close.

The sixteen-foot-high fiery cross atop Stone Mountain could be seen for miles. In the unearthly radiance, the Klansmen surrounded a primal altar of igneous rocks. On it was a silk United States flag carried at the battle of Buena Vista during the Mexican-American War. A copy of the Bible was open. Also nearby were the United States Constitution, Declaration of Independence and the *Laws of the Order of the Ku Klux Klan*. The initiates each took an oath on bended knee. Following a benediction, Simmons duly "knighted" his men with a saber, draped in a silk United States flag, which had been used at the Battle of Seven Pines in the Civil War. Each new Klansman kissed the sheathed sword with a vow to "[t]he Klan, my country, my comrades and my home."

Stone Mountain in black and white never had a starker contrast, and for many people of both races this majestic place would unfairly assume a wildly polarized identity. Later, racism became fraternally institutionalized with a disturbing camaraderie by the revived KKK into American life. Stone Mountain would become for decades an unfortunate new symbol as the Klan's "spiritual" home and a place to which the "Knights" would regularly return. Their meeting place for decades was known as the "Klan Shack" in Stone Mountain Village. Whites nationwide by no means unanimously applauded the revival of the Klan, but southern Gentiles generally welcomed assuagement for the real grief they still felt over the Lost Cause. American Jews, Catholics, immigrants and blacks were understandably uncomfortable as the new Klan, at its "Imperial Palace" in Buckhead northeast of Atlanta, crafted a public image that promoted the antithesis of multiculturalism in America. Klansmen called their exclusive vision "100% Americanism."

The youngest participant that fateful night atop Stone Mountain was thirteen-year-old James Venable, Sam's nephew. James Venable many years later became a KKK imperial wizard and a well-known lawyer, with an office in the Masonic Hall on Decatur Square. Yet he knew and liked blacks at Stone Mountain, who cooked his meals, shined his shoes, cut his hair and washed his clothes. They did not challenge him or other whites in the village in the "culture of localism" spirit. Later, some blacks became his clients. Both races at Stone Mountain understood each other so well that they seamlessly adapted to the social dysfunction of the times, giving the rhythms of their lives separate and parallel harmonies yet constantly intersecting while they worked and loved and reared their children.

HUMAN TRAGEDY: THE 1929 STONE MOUNTAIN QUARRY EXPLOSION

Sorrow shrouded the town of Stone Mountain in perhaps its greatest tragedy at a local quarry on Thursday afternoon, February 28, 1929. "SEVEN MEN MEET DEATH AND SIX ARE INJURED WHEN AIR TANK AT STONE MOUNTAIN EXPLODES," related the March, 1, 1929 *Atlanta Constitution*. The blast at the Stone Mountain Granite Corporation happened at 3:30 p.m., just as workers were checking out for the day. The explosion hurled bodies twenty, thirty and fifty feet.

The published "List of Dead" named white employees—the superintendent and two drillers—first and then the "colored" victims, two drillers, a ledge

boss and a breaker. The paper enumerated white and colored injured as well. Survivors placed all victims on the Dinky train, which sped them to emergency medical care at the village. Physicians from Atlanta and Decatur rushed to help Stone Mountain's Dr. William McCurdy.

Quarry officials thought that the accident had resulted from a failure to adjust the cutoff valve of the huge eighteen- by six-foot steel compressed-air tank, causing its heavy lid to blow into the timekeeper's office, where many were gathered. "One negro [*sic*] was standing on top of the tank," the *Constitution* reported. Fate spared him though: "He was hurled 20 feet into the air, but landed on the ground on his feet and suffered nothing worse than a sprained ankle."

Some citizens thought that a public service for the town in mourning would be appropriate. However, the bereaved families all agreed that they would prefer private funeral rites. As citizens grieved, there was some consolation. The quarry typically employed two hundred, but it had reduced its workforce that day by half due to market demand, preventing unknown casualties.

Life in Black and White at Shermantown

Oral histories of Shermantown in Stone Mountain Village reveal that by the 1940s many black and white children played together. "We went swimming in our birthday suits," laughs Earnest Moore. Going to movies ("The Show," as it was called), they took their segregated seats in assigned parts of the theater and regrouped afterward. Children of different races did not bring one another home, though, and they returned to their own neighborhoods at dusk. Segregated elementary education continued, with blacks attending a four-room schoolhouse in Shermantown, while whites had better facilities. There was no "colored" Stone Mountain High School, so blacks usually went to Trinity High in Decatur or Hamilton High in Scottdale. Various factors meant that childhood social relationships between blacks and whites typically faded during adolescence, a pattern that social scientists have observed.

The great national pastime of baseball brought blacks and whites together at Stone Mountain. Boys of both races played baseball on a lot for "little guys" in Shermantown. As they became "older guys," exclusively black competition emerged between Shermantown's Cubs and the marvelously named Hard Rock team. Opening day was the Monday after Easter, and games drew avid spectators from both races in town. On weekends, one

Direction sign to historically African American neighborhood near the City of Stone Mountain Visitors Center. *Photo by Jennifer Wilkerson.*

team traveled, while the other played home games against black community ball clubs from nearby Lithonia and Scottdale, as well as faraway Lynwood Park, northeast of Atlanta. "It was beautiful," says Shermantown's Henry Schumate. He later could have made the Kansas City Monarchs team in the Negro League but did not stay because he was homesick.

Many black Shermantown residents who moved away or served in the army eventually returned to the neighborhood, for which they still remain nostalgic. They remember a tightly knit community where all adults were parents to all children. To some, the Klan was a yearly occurrence in the post–World War II era on Labor Day weekend, when its members met on a rally field owned by James Venable in Shermantown. Klan members had their "cross lightings" and an annual parade, some marching in regalia and others driving cars on the dirt streets, "whooping and hollering, driving in circles and blowing their horns," Ernest Moore remembers. Most African Americans in a selected group interviewed in a 2005 documentary agreed that "[t]he Ku Klux didn't bother us and we didn't bother them." Blacks knew James Venable as a pillar of the community and were aware that he was a KKK leader, but many considered it "his side of his life."

Yet other African Americans remember conscious intimidation by the KKK and so moved away from Stone Mountain. George Coletti

African American cemetery in historic Shermantown. *Photo by authors.*

and his friends, longtime white residents of Stone Mountain, remember a "Klan Shack" meeting place in the 1960s, but they never attended. Stone Mountain resident Tom Weatherly describes the shack as an "unfinished building." It was located on, of all places, Venable Street in Shermantown. The KKK rallies, Weatherly remembers, were "relatively small," with the largest having "about 150" of the so-called Knights. Ironically, about the time the Klan disappeared from Stone Mountain, in the integrated 1970s, Shermantown began to lose much of its identity as a vibrant African American neighborhood. Traces are visible today, but without the cohesiveness it once had. Only a few older homes and churches remain, and the community became somewhat gentrified in the 1980s.

We may see the lives of blacks and whites at Stone Mountain as lacking and debilitating during segregation, but such were the times they knew. People as always did the best they could, whether in Shermantown or the white districts of Stone Mountain. Life could have been worse. Historians disagree why the Klan revived. Some scholars see the Klan revival—not so much first at Stone Mountain but throughout the United States—as the product of a multitude of phobias nationwide.

Monument to victims of September 11, 2001, located in Stone Mountain Village. *Photo by Jennifer Wilkerson.*

Recalling ringing words of Martin Luther King Jr., the freedom bell is a recent addition to the Stone Mountain Village streetscape. *Photo by authors.*

To cope with potentially polarizing situations, blacks and whites at Stone Mountain taught children, prone to giggle at the absurdity of the men in white sheets, to respect their elders. Perhaps the presence of the patriarchal Venable family offered some sense of protection. It appears that some blacks in Shermantown who were willing to go on the record did not recall being exceedingly fearful of the KKK during their childhoods. Interviewed for an oral history initiative, Shermantown resident Robert Banks recalled watching a KKK automobile parade through his neighborhood; he impulsively "jumped in with my Chevrolet" and drove with the Klan, which made no reprisal to this rare provocation. Others, who left the area, recall family stories of being driven out. Some went north as part of the Great Migration of the early twentieth century, seeking opportunities in urban centers. To families who stayed in Shermantown, baseball rivalries were among the life-affirming things that the close-knit community offered in their daily lives.

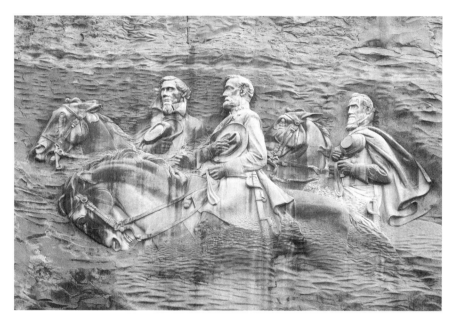

The famous Confederate Memorial carving: Southern heroes Jefferson Davis, Robert E. Lee and Stonewall Jackson, all carved in stone. *Photo © Larry Winslett.*

ℐime Capsule in Granite

THE CONFEDERATE MEMORIAL CARVING, 1914–1970

High on the windswept northern face of Stone Mountain is a steep slope that descends straight down nearly eight hundred feet. Indians had viewed the sheer granite scarp for perhaps ten thousand years, and whites and blacks had seen it for nearly two centuries. So it was until the early 1900s, when southerners began to memorialize a Confederate heritage by hammering, chiseling, drilling, blasting and ultimately sculpting what had been a pristine mountainside.

Since 1970, the north face has borne a unique Confederate memorial. It took six decades to finish, executed in fits and starts by three men. The monument, sculpted onto the granite mountainside in high relief, is the largest of its kind in the world. It makes part of Stone Mountain now a kind of time capsule ("a container with a set of artifacts thought to be representative of life at a particular time"). The carving serves as an artistic, nonstandard time capsule, relating a running story of the 1914–70 years of the South and the nation. Perspectives of it intensified with the 1960s civil rights movement. The idealized carving sometimes appears inappropriate and out of place to those who do not honor the Confederacy. Traditionalists continue to venerate the Confederate Memorial carving.

The memorial is permanent—a heroic, gigantic sculpture depicting three Southern Civil War leaders on horseback. Leading is Jefferson Davis, president of the Confederate States of America. In the center is Robert E. Lee, commander in chief of the Confederate armies. On the right is Thomas J. "Stonewall" Jackson, gifted tactical commander who died at the 1863

Battle of Chancellorsville. Traditional Southern values are represented in the sculpture. Davis and Lee reverently hold slouch hats (Jackson has a kepi, or a flat military cap with visor) over their breasts in memory of their Confederate nation. Davis is astride Black Jack; Lee rides his beloved Traveler; and Jackson, who had two favorite steeds, is on either Little Sorrel or Fancy.

These equestrian figures are set in an area measuring three acres, the size of three football fields, recessed 42 feet into the mountain. The monumental sculpture itself covers about an acre, the size of a large city block. Towering 400 feet above ground level, the carving measures 90 by 159 feet. Someone 6 feet tall could stand inside a sculpted horse's mouth! Though large, the carving is still dwarfed by the hulking mass of the granite dome. An extensive, verdant Memorial Lawn below complements the remarkable presentation.

The impetus for the Confederate Memorial carving was to honor the Lost Cause, once a hallowed Southern ideal. In today's multicultural times, many do not understand the context of the carving and cannot identify the individuals portrayed in it. In the early 1900s, a new generation of segregated southern whites, longing to reconcile the Civil War defeat of Confederates, sought to portray them as chivalrous knights defeated by overwhelming Northern forces. To the white south, General Lee in particular represented noble virtues.

Lost Cause proponents insisted that the true issue of the Civil War was secession, or leaving the Union, as a justifiable constitutional response to Northern economic aggression. Many southerners came to believe that their forbears fought not so much to preserve enslavement but rather for rights of the states to secede. The color of the Lost Cause was Confederate gray, the shade of Stone Mountain's granite feldspars. The north face of the mountain eventually became the container holding and displaying the immense carved tableau of iconic Lost Cause symbols, presenting an exclusive vision with an almost divine mystique in a white-ruled society.

United Daughters of the Confederacy (UDC) was the perfect moral guardian of the Lost Cause. A women's heritage association, UDC, founded in 1895, honored those who served and died for the Confederacy. UDC was an initial driving force for the Confederate Memorial carving. About 1909, Mrs. Helen Jemison Plane was the first to envision a Confederate monument to General Lee at Stone Mountain. Born in 1829 on a plantation in Alabama, she became a Civil War widow when husband William died at Sharpsburg in 1862 and later helped organize the Atlanta chapter of the UDC. She was moved when John Temple Graves of the *New York American* wrote an emotional editorial supporting a Stone Mountain

memorial, which the *Atlanta Georgian* reprinted on June 14, 1914: "Let us chisel a heroic statue, 70 feet high of the Confederate soldier in nearest resemblance to Robert E. Lee."

Mrs. Plane contacted Sam Venable, who supported such a memorial carving on his mountain, and in 1916 she secured from him a lease to the Stone Mountain Confederate Monumental Association as its president. The group chose as project sculptor the noted Gutzon Borglum, born in Idaho to Danish immigrants and a student in Paris under August Rodin (*The Thinker*). Borglum had completed a fine bust of Abraham Lincoln in the Capitol Rotunda, and his reputation was sterling. Invited to Atlanta to visit Venable's summer home, Mont Rest, at the foot of Stone Mountain, Borglum studied the north face. He famously told Mrs. Plane that a sculpture on the vast granite wall would "look like a postage stamp on the side of a barn." Borglum had more grandiose ideas.

GUTZON BORGLUM (1867–1941)
AND THE MEMORIAL VISION

Borglum, as he later related in the January 2, 1916 *New York Times Magazine*, proposed sculpting a "great gray army moving over the surface of the mountain." Davis, Lee and Jackson would lead, facing east—for the dawn of a new day. Other Confederate heroes would head cavalry, infantry and artillery groups, with perhaps one thousand figures in total, ranging from thirty-five to fifty-five feet high.

At the base of the mountain, Borglum proposed building a colonnaded Memorial Hall extending sixty feet into the mountain to honor women of the Confederacy. The focal point in the hall would be a granite sculpture of a southern lady entitled *Memory*. Borglum envisioned *Memory* as monumental in size—as large as the statue for the Lincoln Memorial then under construction.

From the beginning, the Ku Klux Klan had what historian David Freeman terms "circumstantial links" to the plans for the Confederate Memorial carving. The premiere of the popular film *Birth of a Nation* in Atlanta created a local climate embracing the Lost Cause in 1915. Many whites revered the KKK, and film organizers contributed percentage profits of matinees to the UDC for the memorial. Mrs. Plane wrote to Borglum

Sculptor Gutzon Borglum stands near the monumental model of General Lee's head. *George D.N. Coletti Collection.*

on December 17, 1915, recommending that the Klan be "immortalized on Stone Mountain…in their nightly uniform." Borglum already had plans, which included a carving of original Klan founder Nathan Bedford Forrest as a cavalry commander. The sculptor added a "KKK altar" to the Memorial Hall drawings. Relocating to Atlanta, Borglum lived in nearby Avondale Estates, a guest of developer G.F. Willis. At Sam Venable's urging, Borglum joined the KKK.

Left: Gutzon Borglum's unrealized grand plan included a sculpted "army of Confederates" and Memorial Hall dug into Stone Mountain, with a reflecting pool in foreground. *Jennifer J. Richardson Collection.*

Right: Noted sculptor Gutzon Borglum demonstrates proper drilling technique to his quarry-trained workers. *George D.N. Coletti Collection.*

Officials suspended carving operations after the 1917 U.S. entry into the Great War. Afterward, Borglum returned to Atlanta, where in effect he and Venable led the monument association after the aged Mrs. Plane stepped down. They hired E.Y. Clarke, a Klan fundraiser, who established the Southern Advertising Association for his new account. Venable granted easements not only for the carving but also for KKK rallies on the mountaintop. Klan politics continually bedeviled the memorial project.

KKK notwithstanding, Borglum hired black laborers, some from Venable's quarries, and the crews worked together on a platform near the carving area, connected to ground level by a nearly five-hundred-foot-long stairway. Determining a complicated projection concept for the artistic design on the mountain, Borglum was ready to carve his first figure, General Lee. There was an elaborate kickoff dedication on June 18, 1923, before a huge crowd excited about the historic ceremonial start of the Confederate Memorial carving. Virginia governor Lee Trinkle in a keynote address reflected language of multimillennial time capsules and proclaimed an apocalyptic

Ceremonial lunch on the memorial carving of General Lee's shoulder. Sculptor Guzton Borglum hosts Virginia governor Lee Trinkle and dignitaries on the mountain's north face. *Jennifer J. Richardson Collection.*

Carving workers give perspective to Gutzon Borglum's huge sculpted head of General Lee, later blasted off the mountain. *George D.N. Coletti Collection.*

mission. The Confederate Memorial carving, he declared, would "carry the history of our Southern War to a future so distant...age will follow age...our heroes carved in stone, will stand as... the sentinels of time."

Borglum's crews began in earnest with jackhammers, drills and explosives, making the carving an instant tourist attraction. Since 1915, there had been electric trolley service from Atlanta to Stone Mountain. After a 1918 fire, the village received a makeover as charming stone and masonry buildings, many remaining today, replaced older wooden structures. The charismatic Borglum, who made many local public appearances, was a "hands on" sculptor and often was seen swinging like Spiderman on the sheer north face while executing finishing work.

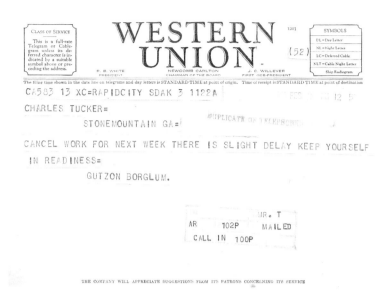

Above: A telegram message symbolic of Gutzon Borglum's unfinished carving delays. *C.J. Tucker Collection, courtesy of Gary Peet.*

Below: A memorial fundraiser half-dollar designed by Gutzon Borglum. When asked about "In God We Trust," his response was, "Because we do." *Photo by Edwin L. Jackson.*

Borglum realized his first real goal: to finish the head of General Lee by the 100th anniversary of Lee's birthday. The sculptor hosted a dizzying luncheon on tables at a scaffold resting on Lee's newly carved shoulder. There dignitaries dined on chicken, hot biscuits and coffee delivered by pulley high up on the mountain carving. On commemoration day, January 19, 1924, a frail Mrs. Helen Plane, ninety-four, arrived, and Borglum gallantly carried her to special seating. Rabbi David Marx of the Temple in Atlanta delivered the invocation. Disquieted by white Protestant rule of

law since the Leo Frank lynching, Marx was a staunch advocate of cultural assimilation, forbidding his congregation from singing *Hatikva*, the Jewish anthem of hope, as a "song of looking back." Marx and the crowd of five thousand looked instead at a giant American flag before the unveiling of General Lee, accompanied by Rebel yells.

Lee's was the only head Borglum completed on the ambitious memorial. His relationship with officials soured after Hollins Randolph in 1924 assumed the presidency of the Stone Mountain Confederate Monumental Association. Randolph criticized Borglum's imperious style and presumed delays. Both Borglum and Randolph were Klansmen but supported different factions after the Atlanta KKK splintered into local and national organizations. Borglum enjoyed the support of Venable and Mrs. Plane.

Exacerbating the conflict was the Stone Mountain Memorial half-dollar project in 1924, the largest federal issue ever of commemorative coins. Borglum, its designer, criticized the association's handling of the coins even as he traveled to Mount Rushmore in South Dakota to prepare for what ultimately became his greatest achievement. The association then summarily fired Borglum, who got the news by phone while at the Stone Mountain carving site with Venable. Furious, Borglum returned to his studio and, according to some accounts, destroyed the Stone Mountain models, deliberately leaving his axe at the scene. (According to others, the sculptor had the contractual right to destroy his models.) Then, tipped off, the enraged sculptor fled to avoid an association warrant for "malicious mischief." In 1926, a bitter Borglum sent a public letter from San Antonio, Texas. He castigated "those responsible in Atlanta broadcasting against the creator of the coin that they may wreck forever the very thing that coin was struck to create and to honor." Although an ignominious end for the first phase of the memorial, Borglum had put forth a monumental vision.

HENRY AUGUSTUS LUKEMAN (1871–1935) AND A NEW MEMORIAL MODEL

Because of public shock over perceived mistreatment of the respected Borglum—the May 15, 1925 issue of *Liberty* magazine called the unseemly flap "The Battle of Stone Mountain"—Hollins Randolph and his association members wanted a low-key southern successor who would be

The second sculptor of memorial carving, Augustus Lukeman (center), created its basic design. *Jennifer J. Richardson Collection.*

the polar opposite of their erstwhile sculptor. They found him in Henry Augustus Lukeman. Born in Richmond, Virginia (though his studio was in New York), Lukeman had studied under the noted Daniel Chester French of Lincoln Memorial fame. Negotiations vaguely implied that Lukeman would complete Borglum's plans. This, however, the newly hired artist never seriously considered, and Lukeman returned to New York to develop a new concept.

Today's Confederate Memorial carving is largely the design of Lukeman. Instead of the action-packed cavalrymen of Borglum, Lukeman opted for leaders in classical heroic rendering, reflectively saluting the Confederate colors. Originally there were to be two groups of Confederate generals, followed by color-bearers. Lukeman's Lee held his hat, emphasizing the legendary majesty of his head, while Borglum had depicted him in a military chapeau. Overall historical contexts differ: Borglum's 1916 plan glorified his Confederates galloping in the moment to defy the Union, while Lukeman solemnly contended that any romance about nations in military conflict had ended with the horrible Great War.

The Confederate Monumental Association hired the Stone Mountain Granite Company to do the actual carving. Owner Albert Weiblen, a German immigrant, eventually designated his son, George, to supervise work. It began with quarrymen blasting out about eighty-five thousand

Left: C.J. Tucker on carving scaffold: "OSHA would have had a field day," his grandson said. *C.J. Tucker Collection, courtesy of Gary Peet.*

Below: The standard uniform patch for carving workers and worn by C.J. Tucker. *C.J. Tucker Collection, courtesy of Gary Peet.*

tons of granite to create a suitable tableau. New scaffolds consisting of beams suspended by cable—all steel—meant that platforms could be raised and lowered throughout the cut-out area. The construction made Stone Mountain even more popular as a destination. In 1926, Atlanta's Memorial Drive, named after the Confederate carving, better connected the city with its country attraction in the emerging automobile culture. Meanwhile Lukeman utilized Borglum's projection device, using steel cables to plot from his model on a 1:12.5 ratio (in inches). Skilled carvers then began work. Lukeman's "hands off" style meant monthly visits from New York with hotel stays in Atlanta and car trips to the mountain. He had touches of acrophobia, ascending the mountainside only as needed.

Lukeman's work proceeded well, with one bugaboo: Borglum's head of Lee remained high over the tableau, seemingly staring at the new carving while another sculpture of the general had emerged below! The association clumsily addressed the bizarre scenario of two heads of General Lee by hiding both with a tarpaulin and making clandestine plans to destroy the one sculpted by Borglum. When his friend, Sam Venable, discovered the scheme, he attempted to restrain it with a court order but failed. In March 1928, the monument association blasted Borglum's sculpture of General Lee's head off the mountain.

On April 9, 1928, the sixty-third anniversary of Lee's surrender at Appomattox, the association formally celebrated Lukeman's work in progress. The memorial carving already had come to mean various things

to different people. A dedication ceremony employed rituals used for time capsules and cornerstones, with guests of honor—including little Robert E. Lee IV, five years of age and great-grandson of the general, ostensibly to be steward of the memory—and huge flags, Confederate and United States, for an unveiling synchronized with the release of doves. Bad weather, hard feelings and long speeches made the event uninspiring. Moreover, Lukeman's sculpture had no finished look. Venable's lease was about to expire with the bankrupt monument association. Historian David Freeman has reviewed the 1916–28 financial statements and concluded that of about $1 million dollars the association collected, only about twenty-seven cents on the dollar went to the memorial. Lukeman never heard anything official again and died in 1935. The memorial stalled for seven years, with no end in sight.

HIATUS AND MEMORIAL PARK, 1928–1963

The Confederate Memorial carving, twice attempted, resembled a broad scar. Yet Stone Mountain was still gorgeous. For example, southern writer Willard Neal remembers the first time "I found the mountain for myself." He was a ten-year-old in the 1930s, when the mountain was a kind of rural Atlanta phenomenon. Neal's visit was on a two-week family automobile tour on dirt roads coming from Alabama. Finally, his dad pointed out the mountain from afar, a "gray shape standing tall above the countryside, with a distinct trail winding through scattered pines up the ridge." Neal remembered the mountain hidden by forests of tall pines bordering a dusty highway. Then, upon approach, the little boy saw a "smooth gray wall" looming almost overhead.

"I have seen larger and taller mountains," Neal later wrote, "but they receded to distant peaks." Stone Mountain, in contrast, "rose boldly out of the earth like a tremendous forehead wearing a perpetual frown." And it had a kind of brow, Neal thought, overhanging so that half of the mountain was shaded in the noonday sun. Looking to the mountaintop, Neal saw in the distance some men, apparently forgetting their woes during America's Great Depression, delighting as they carelessly rolled stones over the summit rim, watching them bound out of sight over the forlorn memorial carving and down the steep north face.

In the grim aftermath of the stock market crash, quarries closed and Stone Mountain became a getaway for Atlanta's unemployed—if they could afford trolley fare and some food. A way to maintain one's spirits was to climb the Walk-up Trail on the west end of the mountain. Near the start of the Walk-up Trail was the Ideal Place, a café and bowling alley operated by a Lebanese American family, the Nours.

The "foreign" Nour boys Elias and Tony were not accepted well in town, and so they played at the mountain, making it their backyard gym. Elias, thirteen, became a legend when he volunteered to be lowered on a rope and saved a terrified tourist hanging on a steep mountainside. From 1927 until 1961, Elias rescued thirty-six people and seven dogs. Embarrassed people usually vamoosed, but dogs were unbounded in their gratitude. Stone Mountain became a kind of informal park where Elias Nour was de

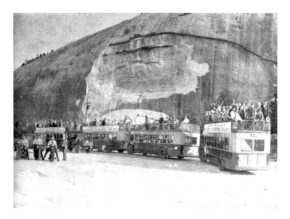

Left: Tour buses at unfinished carving, 1929. Over the years, the Confederate Memorial carving created jobs for many. *Courtesy of Georgia Archives, Vanishing Georgia, cob162b.*

Below: Stone Mountain during the 1920s automobile culture. Highway 78 went right to the base of the mountain. *Jennifer J. Richardson Collection.*

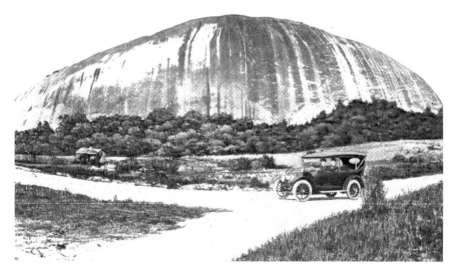

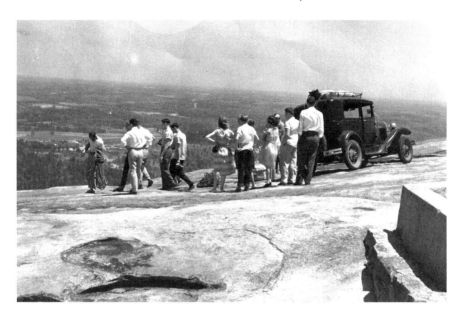

People atop mountain summit; it briefly took their minds off the depression. *George D.N. Coletti Collection.*

Elias Nour barefoot on a slope of Stone Mountain, in perhaps his most publicized rescue. *Elias Nour Collection, courtesy of George D.N. Coletti.*

facto in charge of not only public safety but also special events. Lean and strong, he was athletic—"You didn't want to mess with him," says his nephew, George Coletti.

In 1933, the patriotic Elias stunt-drove a rickety old Ford, labeled "Depression," off the sheer north mountain face, diving out of the careening automobile just in time. The New Deal used publicity photos, and morale shot up. Elias won the 1934 Suicide Derby, a wild footrace down the steep side of the mountain, with an incredible 4:17 time, resourcefully using old steel cables and spikes in front of Lukeman's unfinished General Lee. Nour was two seconds faster the next time, saying that only a wasp's nest

Left: Elias *(right)* and Tony Nour, Lebanese Americans who used Stone Mountain as their "backyard gym." *Elias Nour Collection, courtesy of George D.N. Coletti.*

Below: Nour family and friends at Stone Mountain. Elias drove, and nephew George perches on car headlamp. *Elias Nour Collection, courtesy of George D.N. Coletti.*

increased his speed! Newspapermen loved Elias Nour and took many spectacular pictures of him with only simple ropes, fearlessly defying death and gravity. His dangerous capers, like stunt-driving old cars off the mountain for scrap metal and rubber drives, would be illegal today. Elias went to war in 1942. By the time he returned home, the Stone Mountain quarries had sold the old Dinky train, scrapping its rail tracks to further support the war effort.

During World War II, Stone Mountain became a popular dating place for the many servicemen stationed in Atlanta. On the trolley ride, after Decatur, the driver "let her out" and barreled on toward the mountain at full throttle in thrill rides to start unforgettable days of pure fun. The Georgia legislature, realizing the overwhelming recreation and tourism development possibilities at Stone Mountain, as well as how they could mutually support completion of the Confederate Memorial carving, established the first version of a state authority in 1941 to create a park. After the war, the property remained remote.

Fred Agel, eighty-four, remembers in 1949 climbing to the mountain summit with a hometown friend from Ridgewood, New Jersey. Venturing along the northern rim, Fred suddenly fell, sliding on his back down the sheer slope. Desperately grabbing a random spike "about a foot and a half long"—perhaps from Lukeman's carving—he stopped the freefall. After a harrowing half-hour, Fred pulled himself to safety but not before, he says, he "wore the meat off" both hands. His friend, Fred laughs, gave "moral support."

Postwar feasibility studies for a park commenced with plans to purchase various consolidated Venable properties at Stone Mountain. Both Sam

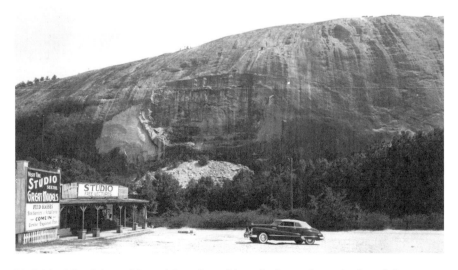

Unfinished Confederate Memorial carving, with studio for tourists at the foot of the mountain, circa 1950s. *George D.N. Coletti Collection.*

Venable and the KKK died during World War II, but in 1946 there was another cross burning atop Stone Mountain, helping launch what historians call the Third Klan. Novelist Pat Conroy in *The Prince of Tides* (1986) described the memorial carving about 1952: "On the side of the mountain, the half-finished effigies of Robert E. Lee, Jefferson Davis and Stonewall Jackson were cut into the stone, incomplete horsemen cantering through granite in a timeless ride." Meanwhile, the South girded for the civil rights movement, leading to epic social adjustment after the 1954 Supreme Court case *Brown v. Board of Education of Topeka* outlawed segregation. Georgia's public officials defiantly responded with cries of "massive resistance" and in 1956 symbolically adopted a new state flag incorporating the legendary Confederate battle standard.

In 1958, the State of Georgia under segregationist governor Marvin Griffin established the Stone Mountain Memorial Association (SMMA), a seven-member state authority. SMMA purchased, primarily from the Venables but also others, 2,500 acres for $1,125,000—a bargain—and created Stone Mountain Memorial Park. The park was later increased to 3,220 acres. The traditional memory of the Civil War motivated state planning, and the upcoming 1961–65 centennial observance rekindled old desires of white citizens to encapsulate time in granite to venerate their southern heritage. The State of Georgia then initiated the final carving construction phase of the Confederate memorial.

Consultant and Closer: Walker Kirtland Hancock (1901–1998) and Carving Completion, 1963–1970

The SMMA advisory board, led by respected University of Georgia art professor Lamar Dodd, launched an extensive national search, inviting experienced American sculptors to submit ideas for the Confederate memorial. Eight men were interviewed in Atlanta. Although competition was for new commissions not on the mountainside, the public demanded completion of Lukeman's model as well. The exceedingly fortunate selection in 1963 was Walker Hancock, whose studio was in Gloucester, Massachusetts. Not only was Hancock one of America's finest sculptors, but also he had true class and the patience of Job.

Chief rigger Roy Faulkner and carving consultant Walker Hancock, the two most responsible for finishing the Confederate Memorial carving. *George D.N. Coletti Collection.*

Hancock's credentials were impeccable. Born in St. Louis, Missouri, he was a professor and award-winning artist at the Pennsylvania Academy of Fine Arts, where he studied under Charles Grafly, America's premier portrait sculptor. Hancock had received the Prix de Rome and had been honored by the National Sculpture Society. His sculptures stand at the National Cathedral, Library of Congress, the Capitol, Supreme Court and West Point. Near the end of his career, Hancock received the National Medal of Art, the highest honor to an individual artist on behalf of the people. When Dodd's committee first contacted Hancock, he was resident sculptor at the Academy in Rome.

In an exceptionally frank and revealing 1977 interview with Robert Brown of the Smithsonian Institution, Walker Hancock incisively described his challenge: "to find a solution for the Confederate memorial." He secured a separate independent commission for an area below the mountainside but realized that "the carving had to be the central motif."

Although a citizen of the world, Hancock was also an authentic son of the South and a member of the Order of Stars and Bars, dedicated to preservation of southern history. Never stating his pedigree until an Atlanta reporter impudently questioned his southern ancestry, Walker Hancock clearly knew whereof he spoke. "I assure you," he later told oral historian Robert Brown of the Smithsonian Institution, "I was not content to call three portraits on a mountainside a Confederate memorial." Nevertheless, his agreement was honor bound "to direct the finishing of the carving." Walker Hancock was always careful to call himself project *consultant*, not sculptor. Whatever final form the memorial might take, it must be as true as possible to the Lukeman

Georgia's legendary secretary of state, Ben Fortson, who steadfastly supported the Confederate Memorial carving. *Courtesy of DeKalb History Center.*

model. As a time capsule in granite, it would inevitably carry wildly mixed messages, even as Hancock took charge with a kind of *noblesse oblige*.

"It was a strange sculptural project," Hancock recalled of the unfinished Confederate Memorial carving. He acknowledged a "handsome piece of portraiture" with "a kind of fine monument quality," and he liked its "out-of-doors character." Although incomplete, the carving to Hancock "unfortunately had been carried so far that there was no going back." He paradoxically felt that his was an "empty appointment," even while having "complete authority on every aesthetic manner."

Hancock's main revision of the Lukeman model was simple and brilliant: to "terminate the lower section in a rough hewn technique." He decided

Yellow daisies on Stone Mountain slope. *Photo © Larry Winslett.*

Above: Primeval Stone Mountain as red hot magma underground. *Image © Taylor Studios, Inc., Rantoul, Illinois.*

Below: Native American projectiles from Stone Mountain area. *Elias Nour Collection, courtesy of George D.N. Coletti. Photo by authors.*

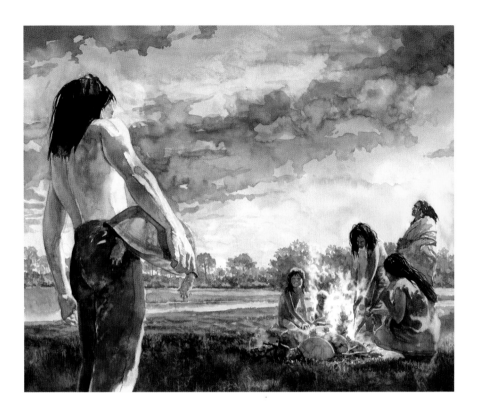

Above: Representation of Paleo-Indians at turtle feast. Turtles were easy to catch and tasty, too. Watercolor by Rob Wood. *Image © Wood Ronsaville Harlin, Inc., Annapolis, Maryland.*

Below: *Skirmish at Stone Mountain, July 1864.* Watercolor by Atlanta artist Wilbur G. Kurtz, circa 1960, in Memorial Hall Museum. *Courtesy of Stone Mountain Memorial Association.*

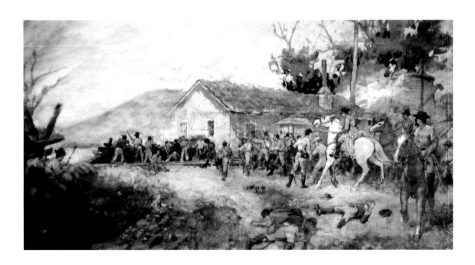

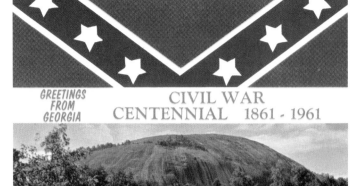

Left: Civil War centennial postcard from Stone Mountain. *Collection of George D.N. Coletti.*

Below: Confederate Memorial carving at sunset. *Photo by Ren Davis.*

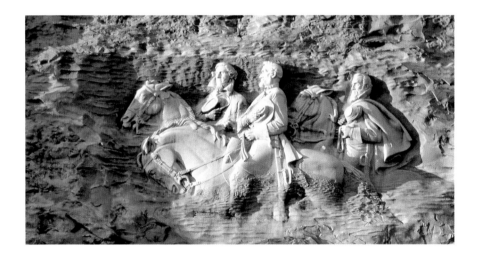

Right: Confederate section, Stone Mountain City Cemetery. *Photo by authors.*

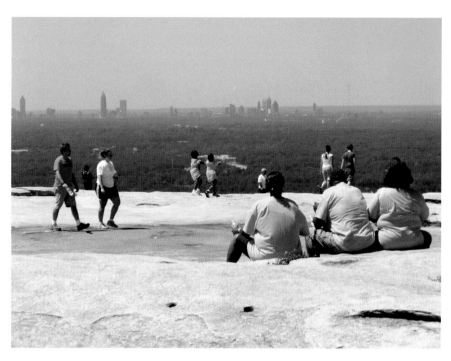

Above: Mountaintop, with Atlanta skyline along Peachtree Road in the distance. *Photo by authors.*

Below: Juliana Pierre in Frances Smith Stone Mountain Community Garden in Shermantown. *Photo © Columbus Brown.*

Above: Cyclists Richard Bakare and Angela Huynh celebrate their engagement at the base of Walk-up Trail at Stone Mountain Park. *Photo taken by a stranger with Richard's iPhone.*

Below: Lasershow Spectacular, which draws more than one million visitors annually. *Courtesy of Stone Mountain Park.*

Above: Family hike in Songbird Habitat. *Photo by authors.*

Below: Timeless Stone Mountain at sunset. *Photo © Larry Winslett.*

Above: Quarry Pond Habitat. *Photo © Larry Winslett.*

Below: Little terrier dog and a huge granite block: Tonto Jarrard wanders through the outdoor quarry exhibit, which has also become a natural habitat. *Photo by Julie Jarrard.*

not to carve the legs of the three horses, which appeared tangled anyway, distracting from the main figures. Hancock's inspiration was his personal photographs from Rome depicting Michelangelo's *Dying Slaves* "partly brought out of the rock," avoiding "stark realism." Besides, Hancock spotted "channels" in the lower tableau that would not yield good carving. He could finish the sculpture faster and improve it artistically.

Hancock's superintendent for the project was George Weiblen, who had executed that role thirty-five years earlier under Lukeman, giving an odd continuity to the project. Weiblen consulted with Elias Nour on preparing the carving area. They replaced everything in the scaffolding area except Lukeman's original steel beams. The work crew consisted of four riggers, with Roy Faulkner as foreman. Postwar technology had advanced dramatically since the last carving attempt, and this time there was an elevator. Stacking one section on top of another created an impromptu shaft of the world's then tallest outdoor elevator. On an adjoining platform was a heated cabin with working refrigerator and sink. Sandblasting lichens off the unfinished carving (which Hancock remembered as "weathered—hardly visible") became the first task on the mountainside.

Organizers planned the dedication for the memorial's second rebirth, on July 11, 1964, with surreal southern touches. A representative for the UDC, recalling the association's venerable Mrs. Helen Plane, dubbed that day "the final step toward the realization of a woman's dream." The new, relatively moderate segregationist governor Carl Sanders keynoted and then signaled the start of work by waving a Confederate flag. Stone Mountain appeared suspended in time—even while Congress worked to overcome southern filibusters for the 1964 Civil Rights Act to prohibit racial discrimination by summer's end. The act foretold a new American promise everywhere, including at the still segregated Stone Mountain Park and village. School integration took place without major controversy, as DeKalb County followed Atlanta's lead in the 1960s. Tom Weatherly, who attended Stone Mountain High, remembers desegregation with two black students by 1966.

Despite any time warp, Stone Mountain's carvers also exemplified the jet age. Their new thermo-jet torches, first used in postwar granite quarries, revolutionized mountain carving. Miniature jets produced roaring flames at more than four thousand degrees Fahrenheit. One carver could do the work of twenty using old pneumatic drills. Hancock had two master carvers, but both left. Joseph Canales never adapted to the scale of such large sculpted figures. His talented successor, Cohen Ludwig, skillfully used shadows and relief for illusions of depth and dimension to resculpt the head of Jackson,

Above: Augustus Lukeman's original model for the Confederate Memorial carving. Walker Hancock subsequently decided, for effect, not to carve the legs of the horses. *Jennifer J. Richardson Collection.*

Below: Legendary Elias Nour was, for a time, the safety director at Stone Mountain Park after it was established in 1958. *Photo by Joseph Dabney.*

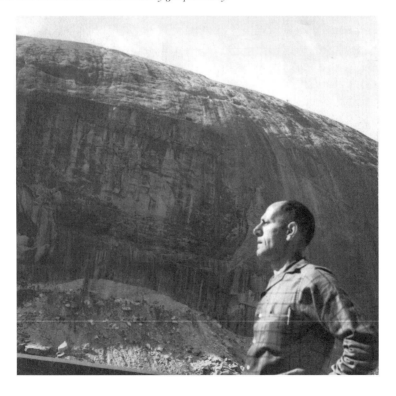

long a problem, but suffered from acrophobia and resigned. Chief rigger Roy Faulkner of Covington, Georgia, extremely adept with the thermo-jet torch, as well as at measuring from the model, stepped forward, but he was "perfectly untrained," Hancock said. A bright ex-marine who dealt with heights and danger well but not with his fellow workmen, Faulkner was to Hancock "the most deplorable egotist I have ever seen."

Stone Mountain, Hancock related in a 1977 interview with the Smithsonian Institution, presented "unforeseen difficulties of such enormous proportions that I will never be able to describe them." Communications were tenuous on his twice-yearly visits because he did not know who was in charge. Stone Mountain, he said, was the "longest, most frustrating and most difficult" project of his distinguished career. Instead of a three-man liaison committee as promised, his group contacts ballooned. Hancock found himself discussing artistic matters with local politicians and even an automobile salesman. He often commiserated with the legendary frustrations of Michelangelo. At the mountain, Hancock had to rely on Faulkner, eventually promoted to carver, who "listened but went on his own way," and so the consultant commenced walkie-talkie communication on site. The best part, Hancock recalled, was ascending the mountainside with Faulkner. "There was real exhilaration going up there at that height," the artist recalled, "in that awe-inspiring setting."

Hancock met his greatest detail challenge—President Davis's hat—which critics said appeared, incorrectly, like the military issue of Lee. A new design required digging out and inserting more granite underneath, patching and smoothing and then sculpting civilian headgear. Hancock successfully directed that last major revision just as contacts with Stone Mountain were vanishing. His subsequent phone inquiries yielded glib assurances that "Roy's gainfully employed."

Finally, Hancock made a surprise site visit to inspect the endless "working on the background" by Faulkner. "Instead of leaving jagged edges that I had made such a point of," the dismayed consultant recalled, "he had neatly smoothed out the whole thing and lined it with a sharp edge like a frame." Hancock felt that his goal for "a solution for the carving that might be aesthetically successful was pretty well dashed." But the great man later saw it with Buddhist humor, laughing about "years of practice of holding my temper when there were times I came close to losing it."

Continuously playing today at Memorial Hall in Stone Mountain Park is an eleven-minute film, *The Men Who Carved Stone Mountain*, showing stills and motion picture footage of two generations doing challenging work—projecting a mammoth scale, climbing about the mountain, carving meticulously, blasting off

the first stone head of Lee, walking high on scaffolds, discarding large pieces of flying granite and, finally, using the critical thermo-jet torches—while individuals under Borglum, Lukeman and Hancock contributed to artistic, technological and engineering dimensions of extraordinary achievement. Ironically, Roy Faulkner, who never had an art lesson, finished the carving. The film contends correctly that the massive sculpture has actually become "a monument to the men who carved it." However, the controversial carving is more than that.

True to its history, the dedication of the Confederate Memorial carving, on May 9, 1970, was rocky as well. Scheduled keynote speaker President Richard Nixon, architect of the vaunted electoral "Southern Strategy," was to make his first major appearance in the region. Unexpectedly, after local newspapers printed souvenir editions anticipating his arrival, Nixon nixed his commitment. News broke of the U.S. Cambodian invasion expanding the Vietnam War into Indochina. Nixon's replacement, Vice President Spiro Agnew, faced charges of income tax evasion in Maryland. He received a cool reception from a crowd of only 10,000 when organizers, according to the May 9, 1970 *Atlanta Constitution*, anticipated 100,000. Also disappointing was the cancellation due to illness of the popular Reverend Billy Graham, who was scheduled to deliver the invocation.

WILLIAM HOLMES BORDERS SR. (1905–1993) AND THE 1970 CONFEDERATE MEMORIAL CARVING INVOCATION

SMMA courageously invited distinguished Atlanta black minister Reverend William Holmes Borders as Graham's replacement. In a serendipitous way, there was a significant multicultural dimension to an important event at Stone Mountain Park, and the event attracted more black citizens than it would have otherwise. The charismatic Borders, pastor at Atlanta's Wheat Street Baptist Church, had been instrumental in the hiring of Atlanta's first black policemen in 1947 and led the campaign to desegregate city public transportation in the 1950s. At long last an African American addressed a biracial crowd of thousands, however briefly, at Stone Mountain. Adding to the drama, it was during a locally televised program.

Earlier, Atlanta media personality Ray Moore of WSB-TV had interviewed Reverend Borders. Never had the nickname for the WSB call

Reverend William Holmes Borders Sr. gives the invocation at Confederate Memorial carving dedication services, May 9, 1970. U.S. Vice President Spiro T. Agnew is on the far right. *Reverend Dr. Juel Pate Borders-Benson and Dr. Elinor Benson, executrix of the Borders estate.*

letters—"Welcome South, Brother"—been so heavy with irony. Soon after the dedication program began, Borders, who had broken the color line on the speakers platform, stepped forward for his invocation. On the sheer north face of Stone Mountain was the Confederate Memorial carving, complete except for a few finishing touches that the naked eye could not perceive. The sculpted figures on the tableau gleamed in the spring sunshine as a time capsule in granite—not only of the Old South and the Lost Cause but also the culmination of nearly six decades of planning and work. As the minister began to speak, a sense of history was palpable.

"Our Father," Reverend Borders intoned, "We thank thee for the United States, your nation and our country." He paid due homage to the Confederate icons carved in stone. "We thank thee for Robert E. Lee, Stonewall Jackson, Jefferson Davis," Borders declared, but he did not stop there, adding to his litany Union heroes "Abraham Lincoln and Ulysses Grant." The southern audience stirred but said nothing. Reverend Borders reconciled the successful Apollo space mission of a year earlier with the unfinished business of finding decent places to live in the nation's urban centers: "Help us to know that mastery of the moon and clearing of slums are not mutually exclusive." Finally, the eloquent Borders boldly exhorted his biracial audience to seek an American promise: "Help us to be the quality nation, whom God can trust to give freedom to the world." Church supporters of Reverend Borders at Atlanta's Wheat Street Baptist Church recall the Confederate Memorial carving dedication as a "controversial event," but his eloquence has well withstood the test of time.

While Atlanta cultivated its image as "A City Too Busy to Hate," the KKK at Stone Mountain persisted. Imperial Wizard James Venable had asked that Borders be removed from the program as "a member of the negro [*sic*] race," arguing that it "was not in good taste and repugnant to a sense of respect due the memory of confederate [*sic*] veterans." The *Constitution* gleefully printed Venable's statement, grammatical errors and all, and when the Klan boycotted the ceremony, it made for a better day. Controversy over Reverend Borders nicely foreshadowed Governor Jimmy Carter's inaugural address of January 1971, when he famously stated, "I say to you quite frankly that the time for racial discrimination is over."

"Granite Could Not Stop Time"

Like all good outdoor time capsules, the Confederate Memorial carving has a preservative. In 1971, Governor Carter painted a ceremonial daub of a silicon repellant concocted by Union Carbide Corporation, after which Faulkner's crew eventually applied several coats. After forty years and into a new millennium, the carving has worn well. Today it has supporters and detractors, but the vast majority of visitors to Stone Mountain—younger and more multicultural—casually accept the carving. In daytime on the Memorial Lawn, scattered crowds gaze and then turn their backs to it as a photo opportunity. As historian Grace Elizabeth Hale contends, "Granite could not stop time."

The most popular attraction at Stone Mountain Park today is the nighttime Lasershow Spectacular, which runs through the summer and has given a new life to the carving. It is used as a unique backdrop, a granite screen. Thousands throng the Memorial Lawn, and when the lights are lowered, people exult in unison as the mountain first becomes dark. Cheers rise when lights beam onto the carving. Pyrotechnics add to the effect, and sometimes the mountainside is clouded in smoke. Near the end of the show, lasers project a lighted moving outline of General Lee, and the presentation shows him dismounting Traveler. Lee raises his sword and then dramatically breaks it, while a laser map shows northern and southern states coming together as one nation. The presentation is done to the musical accompaniment of "Dixie,"

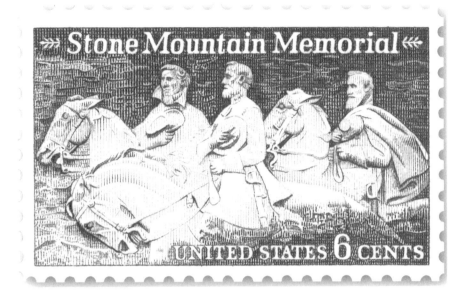

A U.S. commemorative stamp for the Confederate Memorial carving. *Photo by Edwin L. Jackson.*

morphing into the "Battle Hymn of the Republic," both sung by Elvis. This updated message for the carving is fueled by more pyrotechnics in a fantastic finale featuring Sandi Patty singing the national anthem. This updated American twist for the carving is always well received with enthusiastic applause.

"Ride the Ducks." Amphibious World War II surplus six-wheel-drive vehicles travel on both roads and lakes at Stone Mountain Park. *Courtesy of Stone Mountain Park.*

Contemporary Stone Mountain Park

HOW IT CAME TO REALLY ROCK

After about 280 million years, Stone Mountain—fittingly surrounded by a spectacular landscaped environment within a predominately natural setting— entered our own new millennium. After private ownership ended in

Highway 78
Stone Mountain, GA 30086
770-498-5702
www.stonemountainpark.com

1958, the new Stone Mountain Park emerged. Like its memorial carving, the park often endured controversy while grappling with social changes and growing pains. Today it is a true "People's Park."

PREPARING THE PARK

When Stone Mountain Park began in 1958, most white Georgians saw the South as a distinct region, with folkways that outsiders could not understand. Nearly all regional leaders had pledged to defend racial segregation with "massive resistance" to any social change, even while they often were in other ways progressive. The state summarily banned the Ku Klux Klan from the park.

The first orders of business for the new Stone Mountain Memorial Association (SMMA) were grim: constructing rudimentary segregated picnic facilities and building the Stone Mountain Correctional Institution. The prison, now closed and removed, housed about one hundred convicts under Warden Hoke Smith to serve as a labor force for park projects. A priority was building an earthen dam for Stone Mountain Creek and two other streams to create the stocked 416-acre Stone Mountain Lake.

Major construction necessarily waited for relocation of old U.S. Highway 78, for decades the route to Stone Mountain. Jim Helms of Clarkston, Georgia, remembers, "When I was a kid the road went right up to the mountain. I looked up one time [on a family trip], and there it was." Rerouting the highway one mile north would make for more ordered park access by automobile to a new fourteen-mile park road system. By 1960, enough of the Stone Mountain Freeway was complete to build the park. Governor Ernest Vandiver at the lake dam dedication likened the park to a "shrine [in memory of the Civil War]" that would be realized soon. A goal had been to complete much of the work by 1961 for the Civil War centennial observances that stretched until 1965.

The Park as Confederate Memorial

"State politicians formed Stone Mountain Park," contends historian Grace Elizabeth Hale, "as part of an effort to ground the white southern present in images of the southern past, a sort of neo-Confederatism, and halt nationally mandated change in the region." Certainly the new roads clearly underscored Stone Mountain Park's commemoration of the Confederacy, honoring figures of the carving. The main route around the mountain is Robert E. Lee Boulevard, the east gate entrance is Jefferson Davis Drive and the road behind the lake is Stonewall Jackson Drive.

The main administrative buildings, built about 1962, glorified the South in the Civil War as well. The handsome Confederate Hall, ostensibly constructed of Stone Mountain granite but more likely from Lithonia gneiss, with partial stucco façade, has Greek Revival columns in a unique, neo-antebellum southern style. Reporter Fran Fossett in 1970 described the museum as a "meditation chamber full of the Confederacy's giants." A life-size equestrian statue of Robert E. Lee was the focal point. Other

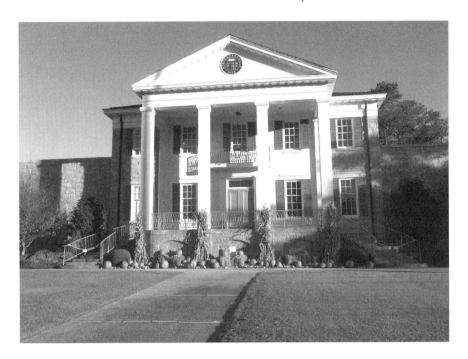

Confederate Hall, built in 1962 as a Civil War museum and now an educational and environmental center, during fall Park Pumpkin Festival. *Photo by authors.*

Confederate generals—Nathan Bedford Forrest, Joseph E. Johnston and John Bell Hood—were prominent in the original museum as well. All have since been removed.

Memorial Hall was never cut into the mountain, as Gutzon Borglum earlier envisioned, but it does have an impressive southern colonnaded style reminiscent of earlier plans. Its nearby knoll location offers a commanding panoramic view of the carving area on the north face. The first park administrative buildings, with their antebellum southern architecture, under the 1956 State of Georgia flag closely resembling the Confederate battle standard, reflected the memorial themes to which the park was committed. Its scenic maps labeled the entire site the "Stone Mountain Confederate Memorial."

Stone Mountain Park's seminal development, with its devotion to old reverence for the Lost Cause and reinforced by contemporary Civil War centennial observances, led to an extraordinary project, the actual re-creation of an antebellum plantation. Park officials boasted that "Stone Mountain Plantation is as genuine a reproduction of a pre–Civil War Georgia plantation as research can make it." Carefully selecting numerous

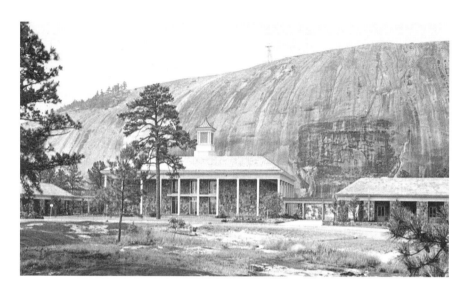

Above: Vintage postcard of Memorial Hall, Stone Mountain Park. *George D.N. Coletti Collection.*

Below: Living history exhibit of the Big House at Stone Mountain Plantation, an authentic antebellum buildings complex relocated to the park. *Photo by Julie Jarrard.*

Noted actor Butterfly McQueen of *Gone with the Wind* fame had a short, ironic career as a tour guide at Stone Mountain Plantation. *Courtesy of DeKalb History Center.*

intact structures of the antebellum past from around the state, authorities relocated them to a park plantation complex on Robert E. Lee Boulevard across the street from Memorial Hall. The 1840s Big House came from the Dickey Spring Creek Plantation near Albany, Georgia.

Unlike traditional Lost Cause interpretations, Stone Mountain Plantation did not downplay enslavement. There were "two slave cabins" (one with a loft for sleeping), from the Graves Plantation in Covington, Georgia. "Actually, a plantation the size of this one," an early Stone Mountain Park brochure explained, "would have had more slave quarters than this, as some 100 hands would have been necessary to keep the place running." The overall historical presentation at Stone Mountain Plantation waxed nostalgic. Reporters later noted the "sounds of hoopskirts rustling on the walk" of southern belle hostesses.

When the plantation attraction opened in 1963, there was heavy irony. Park officials hired Butterfly McQueen of *Gone with the Wind* (1939) film fame—

immortal for her performance as the hysterical and lying Prissy who in dialect finally admitted "I'se don't know nothing 'bout birthing babies"—for the incongruous position of a weekend tour guide. The gifted and introspective McQueen, with a background in drama and dance (earning her nickname that Thelma later legally adopted), had been hailed by the December 3, 1937 *New York Times* for "extraordinary artistry." Ten years later, McQueen announced she would no longer accept "handkerchief head" stereotypical acting parts as maids. It nearly cost her career. For years she accepted a variety of odd jobs to survive and, with her family in Augusta, Georgia, worked at Stone Mountain Park part time. Her star power overwhelmed the plantation, so park officials featured the "Prissy" character as an attraction, which she deplored. McQueen left Stone Mountain Park in 1965. She found suitable stage acting work in New York, earned a degree at City College and received a 1979 Emmy.

As attractions at the park multiplied, a big hit was the Stone Mountain Scenic Railroad, which opened on Confederate Memorial Day, April 26, 1962. It first took tourists only as far as the quarry area and back, once serviced by the old Dinky train. In 1963, the Scenic Railroad received its last link after the blasting of 250,000 cubic yards of rock. It made for a five-mile track around the mountain, the "first full-size park railroad," the route the popular train currently takes.

It was important to give park attractions a Confederate twist, and the inspiration for the railroad was Walt Disney's 1956 Civil War film *The Great Locomotive Chase*. Yet scripts mixed historical metaphors in summer seasons with mock Indian raids at the halfway point, where white actors in war paint brandished tomahawks at "damsels in distress" planted on the train. "We

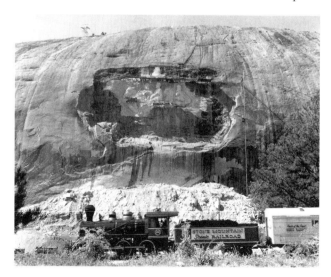

Stone Mountain Park Scenic Railroad (1960s vintage) follows the old quarry Dinky train route, past the unfinished carving. *Courtesy of DeKalb History Center.*

United Daughters of the Confederacy in 1964 donated to the park this Flag Terrace of their heritage. It helps mark the start of the popular Walk-up Trail. *Photo by authors.*

aim for good slapstick family fun," manager A.H. McAfee said in 1970, and the inspiration was the old three-ring circus. Brothers Taric and Adam Mirza remember the "raid" as hilarious when they were boys.

Despite multicultural miscues, the original Scenic Railroad boasted sophisticated equipment to warm the hearts of true train lovers. Its engines included the *General II* (1919, Red River and Gulf Railroad), *Texas II* (1922, converted wood-burner, San Antonio and Arkansas Pass Railroad) and *Yonah II*, a Civil War replica engine. The passenger cars were interurban coaches with observation platforms, steam heated in winter, with roller-bearing wheels from the Chicago Northwestern line. There were two vintage cabooses. Legendary Atlanta artist and historian Wilbur Kurtz, who had been consulted for *Gone with the Wind*, redesigned the coaches. He mixed bright paints for both them and the engines in colors characteristic of the nineteenth century. Kurtz also designed the delightful and bright Victorian Walk-up Station and the nostalgic Memorial Depot. None of these collector features of the old Scenic Railroad is in use today.

The times were changing in 1963, but the following year, United Daughters of the Confederacy (motto: "Love Makes Memory Eternal") erected a Confederate

Flag Terrace that still helps mark the start of the mountain's Walk-up Trail. The monument features the familiar red Confederate battle standard in addition to the Stars and Bars and other southern flags surrounding a towering United States Old Glory in a fine visual history lesson. "Remember: Stone Mountain must always be Confederate," a UDC member advised in a 2010 interview. Notions of Stone Mountain Park as a Confederate memorial had been for the most part fulfilled for the 1961–65 Civil War centennial celebrations. The incomplete status of the carving did not detract, for there remained great hope and interest in it. "Work on Stone Mountain Carving to Resume" Atlanta writer Joseph Dabney headlined an update article for the July 5, 1964 *New York Times*. There was still confidence among many white citizens that the new park would ultimately deliver on a true Confederate memorial. Even as a work in progress, it was always a tourist attraction. As it turned out, visitors would see the carving emerge in stone for the next six years. Meanwhile, thousands poured into the park oblivious to the Lost Cause—they wanted recreation.

UP THE WALK-UP TRAIL (BEGIN BEHIND CONFEDERATE HALL)
One Indian trail remains essentially the same today as it was during prehistoric times, and this trail is still used only as a walking route. It is the trail to the top of Stone Mountain, following the western slope course of least resistance.

Life during wartime: U.S. Army troops start a hike up the Walk-up Trail, 2010. *Photo by authors.*

Walking the 1.2 miles to the top of Stone Mountain is a simple perennial pleasure, for the biggest attraction of the park for hikers will always be the massive mountain itself. The unearthly adventure

begins on granite. (At some point, park officials painted a glorious yellow broken line as a directional. A white line is for emergency vehicles.) Ledges sometimes appear with steep, sheer steps. The scarred mountain has some fissures worn deep—places to avoid. There are occasional pieces of quite large, round, flat rocks that have flaked off.

Soon the resistance of the mountain is apparent. With uneven surfaces, a good technique is to lean forward, establish rhythmic breathing, swinging arms to propel and balance and keep the eyes lowered for safe footing. If the body undulates smoothly in motion, positive thoughts become mantra. Often one hears a babble of languages—Spanish, German and Japanese—on the trail. Climbers laboriously etched elaborate inscriptions onto the granite over the centuries. As the brain becomes oxygenated, fleeting images of these carved words stimulate soulful imaginations about the lives, loves, beliefs and hometowns of countless mountain aficionados who have trod the rock. Elias Nour's name shows up; others include Charlie Bradfield, December 27, 1913; H. Karr of Ann Arbor, Michigan, 1976; and three Thompsons representing 1885 to 1938.

Gasping for air: hikers begin steepest part of Walk-up Trail in a perennial affirmation of good health.
Photo by authors.

The unofficial halfway mark is a picnic shelter with stone steps. Next one crunches over crushed granite. Immediately afterward, the incline markedly steepens, intensified by the surreal appearance of a prolonged moonlike surface, which creates an extraterrestrial effect. Walking somewhat sideways on a mountainside taper and ascending

A multicultural park: Gulshan Haqiq wears Pakistani shalwar kameez at the Top of the Mountain building. *Photo by Usman Mirza.*

even steeper, look for a long pair of railings that proceed up to the unofficial Buzzards Roost, a patch of hardy scrub pines growing in indented granite soil. Here some hikers pause to rest on oversized flat rocks. A tilt of the neck reveals, up at the summit, a public television transmitter (GPTV, Atlanta).

No matter how much fitness or energy one has, there's inevitably the gasping, with legs silently screaming, but the treat is…ah, cresting the mystical mountaintop, always a redemptive moment. "As we stood on the granite summit with the light coming through Georgia," novelist Pat Conroy wrote in *The Prince of Tides*, "it seemed as if the whole world had spread out beneath us." One inevitably reflects on those in time immemorial who came there first; today, though, amenities are available at the Top of the Mountain building to refresh. Outside, winds meet the mountaintop with a tremendous sweep, cooling on a warm day or serving as perfect windbreaker weather when chilly. Around the north-end summit is a safety fence, established by Elias Nour when he was the park's first safety director. Look out and down, enjoy the view and see the Appalachians on a clear day and the skyline of Atlanta along Peachtree Ridge.

BROADENING PARK APPEAL

There were some popular notions that Stone Mountain could be more than a Confederate memorial. For example, the annual sunrise Easter service on the mountaintop dates from 1944, when the Stone Mountain Ministerial Association began nondenominational services. African Americans, celebrating impending double victories during World War II over fascism with a promise of civil rights, were welcomed. The Walk-up Trail became an annual pilgrimage,

"Let the song be sung on mountain's high." The popular Easter sunrise service atop Stone Mountain. *Photo by authors.*

as people from all walks of life made their ways up the moonlit mountain before sunrise, when services began with song at 7:00 a.m. For more than six decades, as morning has broken, Easter traditionally begins with song on the mountaintop as everyone appears to be eye-level with the sun.

After 1962, the mountaintop became accessible to all with what was initially called the Stone Mountain Skylift. Dedicated by Swiss ambassador August Lindt, it symbolized the ultimate in modernity. Imported from Switzerland, which has an unparalleled record for mountain safety in the Alps, gondolas holding fifty-five guests zoomed past the memorial carving area in a three-minute trip along the longest Swiss-built cable car route in the United States.

As people poured into the park and times changed, it became impossible to maintain racial segregation—it contradicted warm welcomes to tourists. The 1964 Civil Rights Act legally prohibited discrimination, and the State of Georgia was obliged to obey the law. There are no dramatic stories of integration at the park because authorities quietly took down old Jim Crow signs, and many blacks and whites were relieved.

The main controversy at the park in the mid-1960s was not the race issue but rather mismanagement by authorities. The upscale antebellum-styled

The "aerial cableway" to mountain summit, 1962. After several generations of cable cars, the post-Olympic model is called Skyride. *Courtesy of DeKalb History Center.*

Stone Mountain Inn, completed behind schedule in 1965, cost twice the nearly $1 million allocated. It was clear that the park had business problems, yet in other areas in the mid-1960s it improved. For example, in new living history presentations, the park wisely chose themes with updated perspectives "from the bottom up." With a new role as "Storyteller of the South," the park selected preservation of historical structures relating to all Americans as reconstructed "Lakefront Attractions."

The Stone Mountain Grist Mill is a valuable reminder of the bygone days of the nineteenth and early twentieth centuries. Then, mills were practical necessities and also places for socializing as folks waited for grain to be ground into meal, flour, grits or animal feed. Mills, typically constructed of heavy timbers, usually had large water wheels to power meshing grindstones. Preservationists dissembled one of the state's few surviving gristmills, at Ellijay, Georgia, and relocated it to Stone Mountain in 1965. Its water wheel projects the sound of moving water, which visitors can hear upon approach.

Another fine lakeside attraction, the nearby Stone Mountain Covered Bridge, symbolizes small-town rural eastern America in the nineteenth century. Commonly used to cross rivers and creeks, these single-lane bridges had roofs and enclosed sides, with closely spaced diagonal elements to form lattices. Originally built in 1892 to span part of the Oconee River in Athens, Georgia, this "lattice bridge" served as a crossing and storm refuge. Relocated in 1965 in an $18,000 project, the sturdy bridge is now a fantastic

Above: A lakeside attraction: the relocated nineteenth-century Grist Mill, which features rushing water sounds. *Photo by Ren Davis.*

Below: Another lakeside attraction: a relocated Victorian-era covered bridge. This kind of structure was sometimes called a "kissing bridge." *Photo by authors.*

investment where history lives. Still operational, with a four-ton weight limit, it offers cars a picturesque covered crossing over a narrow passage of Stone Mountain Lake to Indian Island.

Providing visitors with an unusual musical treat, Stone Mountain Carillon, tucked away on a lake peninsula, also has 1960s origins. Originally created for the Coca-Cola Pavilion at the 1964–65 New York World's Fair, the thirteen-story redwood and steel tower with 732 bells, dubbed Carillon Americana, was a donation to the park. With ten sets of bells and a range of sixty-one musical notes, and with tunes ranging from popular to classical standards and Westminster chimes as well, the Carillon is a constant source of delight. A modern-styled glass organ house for the keyboardist is located nearby. The Carillon concerts serve as "a symbol of friendship and an inspiration for the enjoyment…of all visitors to Stone Mountain Memorial Park," a 1965 plaque proclaims.

The pleasing Carillon bells take on a special character in the annual winter holiday season, when the park is decorated in tasteful white lights reflecting off the mountain and lakes and through the evergreens. The slender, graceful Carillon tower presents a charming visual image year round when the sun illuminates its pastoral lake setting with a perfect view of the mountain.

Early view of Carillon Americana, from the 1964–65 World's Fair, a gift to the park from the Coca-Cola Company. *George D.N. Coletti Collection.*

MEMORIAL LAWN, TERRACES, PLAZAS AND VALOR AND SACRIFICE GARDENS, 1967–1978

Authorities had given consultant Walker Hancock a commission to complement the mountainside carving with an elaborate ground-level memorial landscape design. His most prominent features were to be two illuminated bronze towers near the mountain to frame the view of the carving. Intended to represent Confederate civilians and military, each was to have at its base life-size figures, a woman with child statue metaphorically named *Sacrifice* and a man, *Valor*, who holds a broken sword. The project was unpopular to some. "We know we were defeated," one UDC member spiritedly told Joseph Dabney writing for the *New York Times*, "and we don't have to have a bronze statue to remind us." Others are more casual. "We didn't lose the war," North Carolinian John Siler says impishly, "we're just still waiting on supplies." Hancock's Valor and Sacrifice Gardens are not among the well-known attractions at Stone Mountain Park.

Another part of the plan became one of Walker Hancock's great legacies: the Stone Mountain Park Memorial Lawn. A gentle verdant slope descending from the Memorial Hall granite and concrete plaza, this rolling natural amphitheater extends down and past the railroad tracks. The lawn affords a spectacular view of the north face, carving, summit and slopes of Stone Mountain. Meticulously maintained (closed three mornings a week for grooming), the Memorial Lawn provides a wonderful place for everyone to stretch out and enjoy the view. The Pennsylvania firm of Griswold, Winters & Swain served as landscape architect for Hancock, and it made the project redemptive for the frustrated artist. Firm staff were "perfectly wonderful, fellow designers," he remembered, who "saw possibilities in landscaping."

Walker Hancock's *Valor* statue and garden, honoring the Confederate military, underneath a white-streaked sky. *Photo by authors.*

Walkways on both sides of the Memorial Lawn reveal Flag Terraces for the thirteen states that "seceded" from the Union

(Kentucky and Missouri, sympathetic to the Confederacy, never seceded, but they are also included). State flags serve as focal points, and secession and readmission dates are engraved in stone. The Memorial Lawn complex, dedicated in 1978, is one of the last monuments to the Lost Cause. Despite the pervasive Civil War historical context, not once are the horrors of slavery or the promise of emancipation referenced.

TURN OF THE MILLENNIUM: STONE MOUNTAIN PARK COMES OF AGE

The Memorial Lawn and the mountainside carving met their perfect match in 1982 with the introduction of the Lasershow Spectacular, the most attended attraction at Stone Mountain Park. The show is presented throughout the summer up through Labor Day and again in early October. Lasers (Light Amplification by Stimulated Emission of Radiation) emit electromagnetic visible rays in beams manipulated by lenses projecting onto the north mountainside while creatively using the memorial carving as a giant screen. Adding to the dramatic presentation are recorded popular music and huge fireworks displays. At first, the show had green lasers only, eventually beaming multiple colors. Crowds of thousands have congregated on the lawn on warm nights for years now in one of the park's most cherished traditions.

Stone Mountain Memorial Association (SMMA) was gradually becoming more updated, efficient and professional. In the early 1980s, it eliminated the use of concessionaires, terminating a bewildering array of privately owned subsidiary businesses with everything from an ice skating rink to a petting zoo. SMMA bought out the best concessions, meeting thematic objectives of the park while streamlining operations to maximize profits, such as the Skylift and railroad. The park in 1987 replaced the old wooden train stations with today's modern brick structure modeled after the 1854 Atlanta depot that Sherman destroyed. Today, maintenance at the park is extremely proactive. According to the May 27, 2010 *Atlanta Journal-Constitution*, SMMA undertook a $4.1 million restoration of the Memorial Lawn, updating sound and light equipment, clearing out unwanted trees, adding about thirty-five thousand square feet of new Bermuda turf. "This right here is the heart of the park," said Curtis Branscome of SMMA, "and it should be pretty."

Kathy Wilkerson lines up a shot on a putting green at the Stone Mountain Golf Course. *Photo by Jennifer Wilkerson.*

Another strategic decision was to promote events featuring the lovely setting of the mountain area, including its outlying meadows. The Yellow Daisy Festival, which originally began as a Decatur Garden Club picnic in 1960, has evolved into one of the largest arts and crafts shows in the Southeast. Other early events were the Highland Games celebrating Scottish and Celtic ancestry and, of course, Fourth of July fireworks. Newer multicultural events added in the 2000s include the Indian Festival and Powwow, KISS Family Soulfest, Feria Latina and Summer at the Rock for children.

With coherent planned growth and self-liquidating bond issues, the park in 1989 had built the beautiful and fully equipped 250-room Evergreen Conference Center on the eastern shore of Stone Mountain Lake. The nearby Stone Mountain Golf Club features two public courses designed by Atlanta legend Bobby Jones and has been rated four stars by *Golf Digest*. By 1996, the park had a well-managed campus that contributed significantly to the Olympic Games in Atlanta.

CENTENNIAL OLYMPICS AT THE MULTI-MILLENNIAL ROCK

Stone Mountain Park, with its experience in tourism and hospitality, in 1996 played a naturally integral role in the most significant event in Atlanta's recent

Champion pilot Joe Jarrard in 1980 with a 1947 Cessna at the old Stone Mountain airport, closed before the 1996 Olympics. *Photo by Gail Jarrard.*

history, the XXVI Olympiad, unofficially called the Centennial Olympics. Most events were in the Olympic Ring, a three-mile circle in downtown Atlanta. Stone Mountain Park, classified in the Metropolitan Atlanta zone, hosted tennis, track cycling and archery. Originally, Olympic Rowing was to be at the park, but the lake was too small.

The Atlanta Committee for the Olympic Games (ACOG) built at Stone Mountain a $15 million state-of-the-art tennis facility, with an eight-thousand-seat center court, fifteen practice courts and four thousand more seats. A high point of the Olympics at Stone Mountain was when two United States players sporting "new looks" became gold medalists. Andre Agassi, who in 1995 had shaved his balding head—breaking his popular "image is everything" style—won the men's championship; and Lindsay Davenport, who had lost thirty pounds to increase her speed, earned the women's gold medal. After the Olympics, the tennis center did not draw, and authorities ultimately demolished it.

Overall the park acquitted itself well at the Olympics, even in the extreme southern heat, and successfully handled crowds upon arrival. Visitors from all nations, especially their first time, are always delighted to see the millennia-old granite mountain, and that never changes. In 1996, the park introduced a new generation of swift cable cars, dubbing them the Stone Mountain Skyride, with gondolas that carried up to eighty guests while giving heavy service during the games.

THE STONE MOUNTAIN VELODROME

An intriguing venue was the velodrome at Stone Mountain Park for track cycling. Michigan inventor and cycling fanatic Dale Hughes designed a one-of-a-kind *portable* velodrome, which ACOG leased. The first of a new generation of velodromes, the 250-meter uncovered track cost only about $1 million, less than a third the amount for a permanent oval. It had a racing surface made of extra-thick polyester/wood laminated panels with maximum banking of forty-two degrees, lightly dimpled for better traction. The velodrome had traditional board track appearance yet was moisture and heat resistant, with optimum surface and texture.

Design engineer Chris Nadovich utilized an intricate computer model employing a high-level symbolic language, Mathematica, to design the remarkable velodrome. Its frame was seventy-five tons, with twenty thousand pieces of steel, cut and wielded into sections using special jigs. The modular track had 236 sections, no two alike, and all parts were assembled seamlessly. "The shape, smooth surface, curvature, banking... required sophisticated equation solving," Nadovich later recalled of his calculations; with Mathematica, he encountered no limitations, adding, "We had complete confidence everything would fit together to form a perfectly closed loop." And even though the pieces had never been assembled until they were unpacked at Stone Mountain Park, workers virtually "snapped" them together according to a detailed plan.

Olympic cyclists at Stone Mountain Park were at first skeptical of the innovative velodrome, but soon they were racing around the oval at more than forty miles per hour. Adding to maximum racing performances was the "pole line," the black stripe that cyclists use to cover the track most efficiently. "In my Mathematica model, that line was one of my constraints," Nadovich explained, "and I was able to design the whole track around it." His computer-drawn, completely flat, "zero bubble" pole line helped racers break twenty-one Olympics records, shattering two world records as well. "You see awfully fast bikes," Dale Hughes noted, "but the real advance in technology happens to be the track."

After the Olympics, the velodrome at Stone Mountain Park was dissembled as easily as constructed, avoiding expensive demolition. "ACOG wanted the venue removed and the park restored to its natural state," Nadovich explained. Today there is no trace of the "green" track where international cyclists raced for gold medals in 1996. The "vanishing velodrome" became one of the great spirits and stories of the park.

An international park: German visitors Guenter and Petra Hiller at Skyride Plaza. *Photo by authors.*

Despite such clear progress, Stone Mountain could never quite shake controversy. Critics correctly noted when a new museum at Memorial Hall conveniently omitted the mountain's Klan past, but exaggerations continued. For example, former Atlanta resident Gary Skarka, in a letter to the editor of the July 23, 1996 *South China Morning Post*, claimed that the KKK had "annual rallies at Stone Mountain Park." Yet that never happened after State of Georgia authority began in 1958. ACOG had opted not to have the old 1956 Georgia flag with the Confederate battle standard fly over its venues, but this prohibition could not legally apply to State of Georgia authorities. The Confederate Memorial carving eerily complemented the state flag. Tourists naturally used the remarkable carving as a backdrop for their photos, perhaps to the chagrin of ACOG.

STONE MOUNTAIN PARK AND THE NEW MILLENNIUM

The Stone Mountain Memorial Association (SMMA), a state authority that is self-supporting and receives no tax dollars, continues to run the park and has since 1958. SMMA has nine board members appointed by the Georgia governor for four-year terms (except for the commissioner of the Department of Natural Resources, who serves in SMMA while holding this position). SMMA has a chief executive officer who supervises day-to-day park operations.

In 1998, SMMA entered into a long-term public/private partnership with Herschend Family Entertainment Corporation (HFEC). Founded in Branson, Missouri, HFEC, headquartered in Norcross, Georgia, is a privately owned company that runs theme parks with a mission to "Create Memories worth Repeating." HFEC introduced Crossroads, the 1870s-themed entertainment and craft village near the mountain, separated by wooded land from the Memorial Lawn area. HFEC manages all commercial operations in the park—lodging, attractions, retail food, merchandise and special events.

The public/private partnership effectively uses modern business efficiency standards for commerce and state government stewardship of cultural and natural resources to promote nature, recreation and history at the park. In 2005, officials amended the Stone Mountain Park Master Plan to reflect differences in park operations and programs that occurred with a shift to a public/private partnership.

In the 1958 master plan, updated in 1992 and amended in 1995, four primary land use districts are designated within the park: Park Center (8.5 percent), Natural (63.4 percent), Recreation/Resort (21.2 percent) and Events (6.9 percent) Districts. Within them, the character and intensity of land use and vehicular access is zoned to be consistent with the underlying themes and land use policies for each district. The plan provides visitors with easy orientation—useful maps and brochures—to activities within the park. The land use plan also functions for general zoning to guide future development within Stone Mountain Park. One of the first growth projects

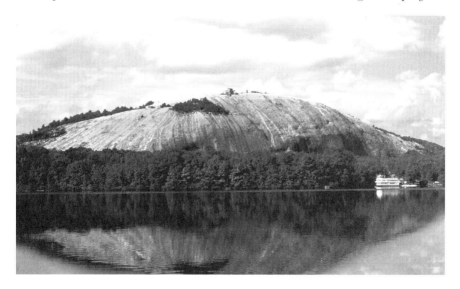

Stone Mountain panorama, with a riverboat on the right. *Courtesy of Stone Mountain Park.*

Father-daughter bonding: boating on Stone Mountain Lake. *Courtesy of Stone Mountain Park.*

under the 2005 plan is the handsome Art Deco entrance to the cable car mountain ride, Skyride Plaza.

"Throughout its existence, the Association has had to deal with tensions inherent in the purposes it serves," wrote G. Curtis Branscome, current CEO of SMMA, in 2007. "It must provide a fitting memorial to those who made great sacrifices and fought with valor for a cause they believed in," Branscome declared, adding significantly, "while also condemning the evils of slavery and oppression that accompanied that cause." And he also noted: "It must provide recreation/entertainment opportunities in a way that makes it financially self-supporting without impinging too much on the natural beauty of undeveloped woodlands and open spaces."

Stone Mountain Park has done a fine job in paying park bills while keeping more than three-fifths of the land natural, all with the help of sound private partnership practices, a practical master plan and thousands who love and support the facility. The United States commemoration of the 150th anniversary of the Civil War, from 2011 until 2015, will be exceedingly relevant to Stone Mountain, which has one of the premier memorials to the Lost Cause carved on its northern face. Today Stone Mountain Park is multicultural and all-inclusive beyond the expectations of any of its 1958 organizers. The park supports its mission to preserve nature, recreation and history under the aegis of a state authority.

The *Scarlett O'Hara* paddle-wheel riverboat, a signature park attraction on Stone Mountain Lake and part of a tradition since 1971. *Courtesy of Stone Mountain Park.*

Contemporary visitors to Stone Mountain Park today—whatever their origins—date back in tangible ways to the first Americans who joyfully visited what are now the park grounds, today a public legacy. While visiting the contemporary park and in the midst of fulfilling activities, one invariably hears at times the bells of its Carillon Americana, ringing for everyone. In a way, it symbolizes the words of the 1963 dream of Martin Luther King Jr.: let freedom ring from Stone Mountain of Georgia!

The challenging, sometimes slippery mountain slope of Cherokee Trail. *Photo by Ren Davis.*

CHAPTER 6

The Natural Beauty of a People's Park

Throughout its long history, the environs of Stone Mountain have been uncommonly beautiful, a unique ecosystem surrounding the gargantuan granite outcrop. Except for its quarry and railroad development, the rugged mountain maintained a marked pastoral character into the mid-twentieth century. In 1958, after Georgia made its epic purchase of the Venable brothers' estates, Stone Mountain Memorial Association (SMMA) established a priority to preserve nature in the park.

BEAUTIFICATION OF THE PARK

In 1958, SMMA commissioned Robert and Company in the village of Stone Mountain for a landscape design of the park. Planning wisely included not only facilities but also a program of habitat conservation in the overall park layout. Emerging during this critical transformation was Harold Cox, an unassuming, scholarly English landscape gardener deeply devoted to both nature and the park. Harold's daughter, Rosemary, recalls her dad and their days at Stone Mountain:

> *My first impression of Stone Mountain as a young visitor in the mid-1950s was baking summer heat and a massive scar, the aborted attempt*

Postcard of Stone Mountain in bloom. *Jennifer J. Richardson Collection.*

at a memorial carving to the Confederacy, stretching over the face of the mountain. Things had not changed much by 1961, when my father became the director of horticulture for the newly formed Stone Mountain Memorial Association, and our family went to live inside the park in a small cottage originally built in the 1920s by the Venable family.

For my father, who had won an award from his school district at the age of thirteen for the best landscape garden design, who held the coveted Kew Certificate from the Royal Botanic Gardens at Kew in London, Stone Mountain posed a challenge: how could he cultivate anything on solid granite? My mother, with her indomitable spirit and pioneer creativity, supplied the answer: raise the garden beds. And that is just what he did. Prison crews from the camp in the park hauled soil excavated from the area that became the lake and constructed the flower beds and rock walls for Memorial and Confederate Halls and later the plantation complex. My father oversaw the construction of greenhouses next to our cottage, where he propagated all of his bedding plants and vegetables for the Kitchen Garden in the plantation, an organic showcase, providing the plantation's most famous vegetarian resident, Butterfly McQueen, with a steady supply of produce. The subject of newspaper features and a "photo-op" for thousands of tourists, the gardens at Stone Mountain Park were a credit to this native Englishman.

It was not cultivated plants, however, but the indigenous flora of this unique granite outcrop that was his passion. Harold Cox catalogued the plants by their

English landscape gardener Harold Cox, who championed emphasis on nature at the park. *Courtesy of Rosemary Cox.*

botanical names, and when he discovered a specimen thought to be extinct, he took a rooted cutting to one of his professors at Kew. He was the first to promote the "yellow daisy" (Viguiera porteri), namesake of the popular festival each fall. And he worked diligently with others, such as Robert B. Platt from Emory University, to preserve natural granite habitats. Perhaps his most significant contribution to this effort is the Nature Garden, which he marked and laid out along New Gibraltar Creek at the base of the mountain and which today bears his name—a fitting legacy for Stone Mountain Park's first horticulturalist.

Cox began work by landscaping the formal gardens of the plantation grounds and other areas with seasonal planting of tulips, narcissus and annuals such as petunias and marigolds. "The most eye-catching flowers we have out here are the daffodils," he noted in 1970; he planted enough bulbs to have a spectacular half a million blooms per year. Cox landscaped the thirteen Flag Terraces and the area around the carving in a display with spectacular colors surrounding the Memorial Lawn, making the entire complex resemble a massive English garden. That work has not survived.

Yellow Daisies

Cox noted extreme reactions by the public to brilliant wildflowers that originally came to be known as Confederate daisies—perhaps they could have gotten this name only at 1960s Stone Mountain Park. Today they are called yellow

daisies. "Everyone passing by," he observed, "admires the masses of bright yellow blooms shining in the September sun." In natural symbiosis with granite outcrops on the Piedmont—it is a wonderful myth that yellow daisies grow only at Stone Mountain—these wildflowers germinate in spring and remain stunted through summer. These hardy daisies persevere through droughts and burst into a glorious yellow carpet with the onset of fall rains.

Cox observed that yellow daisies literally need "starvation conditions to exist." Sometimes he found random seedlings in his cultivated beds at the foot of the mountain—they became lush and then invariably died. Cox concluded that these hardy wildflowers needed "dryness, characteristic of granite rubble…necessary for the plant's cycle." (This irrepressible flower that thrives on adversity is the most tangible floral symbol of Stone Mountain Park. Confederate Hall, which in 2005 assumed its role as an environmental education center, proudly incorporates the yellow daisies into its logo.)

Cox and others feared that as Stone Mountain Park sought an identity in the 1960s it might become what they scoffed as "Six Flags East," aping a then new amusement park in metro Atlanta. Six Flags over Georgia, a popular 230-acre facility west of the city, had opened in 1967 as a multiple-gate theme park in a newly competitive industry with amusement attractions, featuring thrill rides and roller coasters.

Stone Mountain Park tentatively offered some tamer "theme" entertainment. "Mark Twainland," for example, had enticements such as "Visit with Tom Sawyer and Huck Finn in their Tall Tale Cave." Various park concessions became so garish that the June 30, 1967 *Atlanta Constitution* hooted "Stone Mountain Layout Hit as a Coney Island." Officials clearly did not know what kind of park they wanted Stone Mountain to be.

Fortunately, the Natural District, more than 60 percent of Stone Mountain Park designated in the master plan, was kept intact and remains relatively insulated. Making the road circling the base of Stone

The signature yellow daisies that somehow thrive on granite outcrops. *Photo* © *Larry Winslett.*

Left: A one-way road section with recreation lanes in Natural District on Robert E. Lee Boulevard, the roadway around the mountain. *Photo by authors.*

Below: An annotated map of the Natural District covering 60 percent of Stone Mountain Park, updated as of 2011. *Map © Larry Winslett.*

NATURAL DISTRICT

In 1995, the Georgia Legislature enacted measures that set aside the highlighted areas as Stone Mountain Park's "Natural District." These areas contain many wildlife habitats and are protected from future development. They include streams, lakes, rock outcrops, native forest, and fields. Most of the park's trail system is also within these areas, including the Walk-up Trail (7) and the historic Cherokee Trail around the mountain. Other important sites are Indian Island (1), Stone Mountain Lake (2), Venable Lake (3), Howell Lake (4), the Catfish Pond (5), the Bird Habitat (6), and the Nature Garden (8). As new properties are added to the park, they will be considered for inclusion in the Natural District. The Forest Hills Baptist Churh property (9) was purchased by the park in 2010. These properties were added (10) to the Natural District in January 2011.

Mountain, Robert E. Lee Boulevard, as one-way traffic with sidewalks along with "ped" and bike lanes was vital. It helped keep the pastoral integrity of the Natural District and in a sense became an axis with smaller parking lots. This road section—starting past Confederate Hall, heading past Harold Cox's old greenhouse (still standing) and terminating at the roundabout across from the quarry exhibit—serves as a kind of "Main Street" for the district. Its natural areas consist of both old and new wildlife habitats that are protected from future development.

NATIVE AMERICAN PLANTS IN THE HAROLD COX NATURE GARDEN AND ALONG THE NATURE TRAIL

The Harold Cox Nature Garden is in land forested by tulip poplars, hickories, sassafras, loblolly pines and various kinds of maples and oaks. Convenient parking is on the other side serviced by a crosswalk. (Be careful on early weekend mornings, as the one-way street is trafficked with some cars but mainly many walkers, runners, dogs on leashes and cyclists.) The garden, a national landmark in its field and beautifully interpreted, is one of the gems of Stone Mountain Park. A rustic canopy proclaims the garden's namesake and orients nature hikers with a handy illustrated map.

Much of the illustrated caption vegetation interpretations hearken back to Native Americans, creating a kind of epiphany for walkers along the trail. Pungent crushed leaves of mountain mint, for example, were useful in teas to cure fevers, colds, coughs and headaches. The formidable perennial shrub yucca has sharp, pointed leaves from which Indians stripped filaments for baskets, fishing nets and clothing thread, while eating the flowers and boiling the roots for soap. It is a gentle learning experience for those knowing little about mountain plants.

Stream ecology is a world of its own when interpreted in the Nature Garden. From the mountain, gravity pulled water across the earth, carving undulating creeks dependent on heavy rains and runoffs. Deeply carved over centuries, stream life depends on algae, microscopic plants and tiny animals all living in watered rocks and sand. Little shrimp, minnows and clams are in an "eating environment," and less vulnerable insects—such as the confident water strider—appear to walk on the stream.

Rotten log environments are preserved throughout the park's natural district, as they are sources of food and shelter for forest creatures. Pileated

Above: A canopy and information kiosk along Stone Mountain Nature Trail. *Photo by authors.*

Below: Pileated woodpecker at Stone Mountain Park. *Photo © Larry Winslett.*

woodpeckers have softer meals here than hardwoods, on which they make such distinctive sounds. Rotten trees may take ten years to decompose into the dark, moist forest floor. Rotting logs with their holes and cervices help feed salamanders, toads, snakes (careful!) and other animals.

Approaching the mountain base circled by the railroad (sometimes one hears the bells), one sees impressive views of distinctive igneous rock outcrops, where hardy plants such as granite gooseberry shrubs with thorns on stems struggle and thrive. As pieces of granite break loose and weather in temperatures, they expand and contract, just as on Stone Mountain. Plants grow in cracks and become irrigated by years of running water. The big boulders near the tracks are especially impressive—one can clearly see strong little plants taking root.

While descending the highland parts of the Nature Trail, one sees more heavily forested areas typical of the Georgia Piedmont. State authorities clear-cut elevations below the mountain in the 1940s, leaving patches of mature forest and trees up to 150 years old in what ecologists call a stable community. Once barren long ago, it has gone through forest succession of grasses, small wood plants, shrubs and finally majestic trees. There are many kinds of oaks, white, red, black and post and scattered dogwoods. Sweetgum, so called because sap oozes (alas it is bitter) from its wounds, and big leaf magnolia add to marvelous shade on a summer day.

Butterflies abound at Stone Mountain natural habitats. *Photo © Larry Winslett.*

Winding down the trip of the three-fourths-mile Nature Trail loop and returning to the Harold Cox Nature Garden, there are pithy plant interpretations. Lovers will smile at the hearts-a-bursting, with its distinctive colored seedpods that white-tailed deer love to nibble. Indians created one of their most valuable astringents from these leaf stems. The Christmas fern, resembling an evergreen, is a time-honored holiday decoration. So is the universally loved and recognizable American holly. Another perennial symbol—Victorians saw it as immortal—holly evergreen has a whitish wood valued for cabinet inlays. The eastern red cedar, though stunted in its growth at Stone Mountain, had medicinal value to Indians for coughs and head cold. Birds enjoy its berrylike cones, and deer browse its twigs. Similar in its universal popularity is the wonderfully named beautyberry, which Native Americans boiled for sweat baths, and birds and deer love to munch its fruit.

Any given visit on the Nature Trail can be different, with groups, couples, Boy Scouts and others. There are times when one is all alone; and loneliness on the trail can be sublime when songbirds play their happy tunes.

CHEROKEE TRAIL

The Cherokee Trail has multiple access points with marked trail heads in the park nearly wherever there is a parking lot. Designated in 1971 by the secretary of the interior as a National Recreation Trail—to preserve and protect our nation's historic natural pathways while celebrating America's history—the Cherokee Trail loops five miles around the base of the mountain. National

Recreation Trails are intended to bring communities closer together with an emphasis on nature, fitness and family fun. The Cherokee Trail passes primarily through an oak/hickory forest, with placid views of lakes, streams and grand parts where the mountain rears up into view.

The Boy Scouts of America have listed the Cherokee Trail as one of the nation's historical trails, and it is not uncommon to see them with Scoutmasters taking nature hikes on weekends for recreation and to work on merit badges. Much of the trail is a traditional pathway around Stone Mountain that people have trod since ancient times. It is not clear why the trail is named after the Cherokees, as the Creeks-Muscogees historically inhabited Stone Mountain, but there was abundant trade between the two Indian nations at the Stone Mountain crossways. There is a legend that Cherokees peacefully earned the right to extend their hegemony south of the Chattahoochee after winning one of their cherished ball games at the Standing Peach Tree trading landmark at Peachtree Creek.

Unlike on the Walk-up Trail, dogs, which often traveled with Indian bands, are allowed on the Cherokee. Older sections of the trail go through wooded areas having rock-filled, rain-fed creeks sourced by runoff from the mountain over the ages. Other parts of the pathway have a marked pedestrian character, crossing Robert E. Lee Boulevard (to go from one forested section to the next), the Scenic Railroad tracks, picnic pavilions and the man-made lakefront attractions, such as the Grist Mill and Covered Bridge and also the Memorial Lawn. The Cherokee Trail puts these features in different perspective as a hiking tour.

STARTING ON THE CHEROKEE TRAIL

The official beginning of the Cherokee is at the intersection of the Walk-up Trail about five hundred yards from the Flag Terrace as one ascends the mountain. Looking up the mountain, turn right. Cherokee, the cross-trail, is marked with reassuring white blazes (painted rectangles) on trees and the rock. Granite markers have strategically placed red directional arrows. It is useful to have at least a light pack with water, energy bars, the park's official map and perhaps a paperback guide book (maybe this one!). It is also good to carry a cellphone. In case of emergency, call 770-498-5675. There are call boxes along the trail as well. Strike off on the first part, a pine needle–covered path on granite through a wooded area of scrub trees.

INTO THE WILD: STONE MOUNTAIN WESTERN SLOPE

Leaving the light forest of the cross-trail, proceeding over crushed granite and large round-topped slab rocks, hikers encounter the surreal "moon surface" of the mountain. Unlike the resistance of the Walk-up Trail, the challenge is navigating the slope of the mountain taper. Signs warn: "SLIPPERY & HAZARDOUS." Going slowly helps. Lean toward the mountain, locking both ankles (one foot is lower than the other) while examining where you step. In particular watch—and try to avoid—lichens and especially large areas of moisture, sometimes tiny waterfall runoff but more often seepage. Indeed, climbing the mountain always requires caution, and warning signs should be heeded. (On March 25, 2010, the *Atlanta Journal-Constitution* reported that Emory graduate student, Antony Edge, an experienced rock climber, had fallen to his death after apparently venturing past the safety fence at the mountain summit. "All you have to do is slip a little bit, and then you can't stop," said Chuck Kelley, park chief of police, who investigated the accident.)

The bald western slope part of the Cherokee Trail has white blazes painted on granite. On temperate beautiful September and October days under an azure sky, the mountainside is achingly beautiful. There are rugged stunted pines and sometimes hawks and vultures circling high above. Most spectacular in season are abundant yellow daisies that cover the mountainside

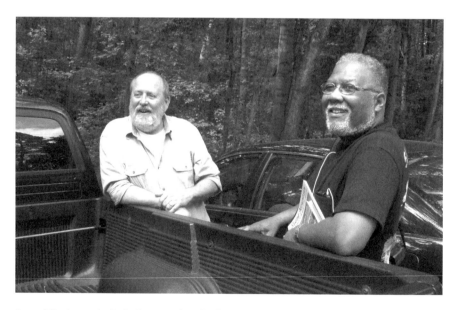

Larry Winslett, principal photographer for Stone Mountain Park, chats with pro photographer Columbus Brown. *Photo by authors.*

in a riot of color. They are, says the park's preeminent wildlife photographer Larry Winslett, "one of nature's great sights, turning whole sections of the mountain into brilliant rivers of gold." Not only do daisies proliferate in broad island communities, but hardy, smaller groups also peek out of crevices between large flat-topped rocks, nice sitting places for a break.

CHEROKEE TRAIL WOODED PATHS AND PARK ATTRACTIONS

Descending the granite surface, there is forest with a large vertical rock creek bed, often dry. However, this rocky runoff transforms into one of the most impressive views on the Cherokee Trail during rainstorms. The trail here is of variegated stone in a gully. True nature lovers visit this habitat in pouring rains, which produce marvelous gushing waterfalls down the steep angle from the mountain.

Much of the Cherokee Trail becomes a wooded path after leaving the mountain area, heading south of the railroad tracks. One landmark is a faux chimney ruin. "The chimney, which can be used to pass the Boy Scout requirement to estimate height, is 17 feet 6 inches high," the official park Cherokee Trail brochure helpfully relates. Here the path doubles as an Orienteering Trail with twenty-three stations. Sometimes one hears the gobbling of wild tom turkeys, and strangely, hikers often hear clear sounds of visitors enjoying the park. There are the bells of the Scenic Railroad and the sounds through the trees from the roadway of conversations of joggers, runners, walkers and bikers, as well as others traveling different trails.

Crossing Robert E. Lee Boulevard into more forest, the Cherokee Trail skirts past the family-friendly playground. From this perspective, the mountain has a mohawk of pines across the top. The trail enters a lake environment, with a dam, spillways, landscaping to prevent erosion, wooden bridges and steps. Passing Howell Lake and Catfish Pond, there is a long stretch of wooded trail past Venable Lake. All are inhabited by mallard ducks, the most common game bird and ancestor of all ducks. Numerous dead trees are left for the great horned owl, which does not build nests but rather seeks cavities in this environment. Athletic dogs love the forest, and sometimes they bound and flush out white-tailed deer roaming free at the park. Bucks grow antlers in the fall, during mating season, and shed them later. With their highly developed senses of sight, smell and hearing, deer communicate

Stone Mountain across the millennia. A plane flies over the ancient granite dome in the jet age. *George D.N. Coletti Collection.*

with tail signals and often gravitate toward creeks. One impressive ancient rain-fed deep-banked creek with a wet crossing runs whitewater over large, smooth granite rocks as it streams toward the lake basin that it helped to form. Vistas on the trail afford gorgeous views. The ancient scarred granite with long blackish stripes from water runoff stands bare, save for scattered patches of scrub forest succession.

Taking an earthen bridge, hikers see Stone Mountain Lake, and somewhere there is an unmarked, watery site of the prehistoric Indian hunting campsite that once was one of the park's fragile archaeological remnants, now sadly lost to the hands of time. Today's lake trail is the typical shore path with gnarly roots, moss and granite outcrops, winding there for about a half-century, though so weather beaten and trod upon that it looks much older. Wonderful environments include the lovely granite outcrop lake banks that have little ecosystems of hardy prickly pear cactus and, in the fall, the ubiquitous yellow daisies so symbiotic with the rock. Scattered among them are narrow-leaf blazing stars, bright purple flowers in vivid displays. The lake's granite outcrop banks, often occupied by hikers, are ideal for short, refreshing breaks. The trail leads to a spectacular living history attraction, the Covered Bridge (on the other side is Indian Island). Such perspectives help hikers who typically opt for the five-mile roadway around Stone Mountain realize something: they can hike the same distance along a rustic trail and view the park's natural environment.

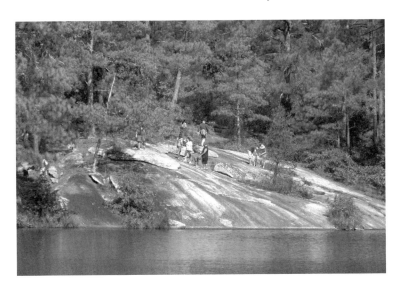

A granite outcrop, with an ecosystem, serves as a bank to Stone Mountain Lake along Cherokee Trail. *Photo by authors.*

From the bridge, part of the trail becomes lakefront landscaped flagstone, and the dirt path heads toward the Grist Mill. Situated on deep-banked Stone Mountain Creek, its approach from the Cherokee Trail on the lakefront offers a different view from the picnic pavilion entrance. The water wheel, thirteen feet, eight inches in diameter, is a faithful reproduction. Millwrights say that such wheels, kept well balanced and in constant use, can last up to seventy-five years, and the water actually helps preserve the wood. The rushing waters of the creek are some of the great constant calming sounds of the park. A short eccentric part of the trail literally follows the wooden walkway around the mill, and then the path follows a marvelous granite miniature aqueduct parallel to the creek, partially landscaped with rocks. The trail along the stream appears ancient, broadening into a lush floodplain that Indians may well have traversed, particularly as it heads toward the mountain.

Crossing Robert E. Boulevard again, the ancient part of the trail still parallels the creek somewhat in the distance. Hiking over the railroad tracks indicates that the mountain is near but obscured by woodland surrounding the old pathway. Finally disoriented and emerging from the forest, one sees a dramatic intersection: the base area of the sheer north face of Stone Mountain with the carving tableau, so steep as to crane one's neck; near the reflecting pool and Valor and Sacrifice Gardens, inclining up a knoll, is the verdant Memorial Lawn! It is the exact opposite perspective than is conventional from Memorial Hall.

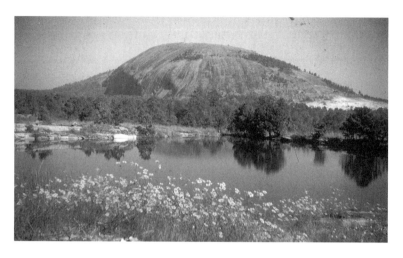

Stone Mountain Lake and yellow daisies, taken by noted Atlanta photographer Kenneth Rogers. *Courtesy of DeKalb History Center.*

Two last stretches of the Cherokee Trail appear isolated and ancient, starting with a forested section heading directly toward the mountain. Ascending the mountainside into scrub environment from the northwestern slope takes one back into the wild again. Trail markers are again painted on the granite, with more challenging terrain than since the official start of the trail. The "SLIPPERY" warning signs emerge as well. Overall the Cherokee Trail is sparsely traveled (an exception is the presence of Boy Scout nature hikes), and when it intersects with the more trafficked Walk-up Trail hikers have completed five miles.

Although the Cherokee Trail does not have the drama of hiking to the mountain summit, it is a very satisfying and comprehensive tour of the park. The mountainside slopes sections are utterly spectacular when they turn yellow with daisies in September and October, the best time to hike. From April to July along the forest edges near the lakes, Cherokee roses are visible. These white wildflowers with yellow stamens form garlands of blossoms on evergreen plants growing up to twenty feet. Although an exotic from China, it is the official state flower of Georgia.

OLD QUARRY HABITAT

The ecological regenerative process of succession has transformed one of Stone Mountain's former industrial sites into a classic quarry natural

Showy ruff of St. John's wort in bloom at the park. *Photo © Larry Winslett.*

habitat. Quarries, with their open-pit mining, have pockmarked environments and, like mines, are eventually abandoned. Rarely are quarry habitats so convenient to view as at Stone Mountain Park. Quarrying ended there in 1978, and for more than a generation now, nature has slowly taken over in a remarkable transformation. The park quarry display not only is instructive for its past but is also redemptive for the future—a new natural habitat has emerged, fringing the exhibit and the slope of the mountain. The ecological succession of lichen, mosses, flowers and trees, fostered by wind blowing sand and seeds into rock piles, makes the old quarry site a rejuvenated natural environment. Rainwater has filled one of the ledge excavations, making it a pool refuge for amphibious creatures, animals and plant species. Many wildflowers of this granite habitat are shades of yellow, including dwarf dandelions and golden St. John's wort, known for its showy ruff. It blooms about June 24, the day of St. John the Baptist.

Naturalists know that the best times to view elusive animal life at all habitats in the park is at twilight. Staying at the park is inviting, at one of the hotels or to camp. The Family Campground at 4003 Stonewall Jackson Drive has all the amenities for RVs, including full hookups, Wi-Fi, laundry and a general store. All habitats are open from dawn to dusk, two times when they dramatically take on their wildlife character. Gray and red foxes, the smallest members of the wild dog family, weighing in at the seven- to fourteen-pound range, are there. Living in dens in rocky outcrops around the quarry, they are swift runners, with excellent senses of smell and sight. They attack the prolific eastern cottontail rabbits, which feed on vegetation on the rocky outcrops in early mornings and late evenings. The most widely hunted and preyed-upon game in America, rabbits rely on their speed, hearing and uncanny ability to freeze in place to survive. The biodiversity

habitat is so radically different from the historical exhibit that there is no wonder that green advocates urge "Support Your Local Quarry!" One can do it at Stone Mountain Park.

SONGBIRD HABITAT

Once the venues for Olympic track cycling and archery, this newest trail area in the Natural District, restored in 2002, is now an official National Wildlife Federation Schoolyard Habitat site. Entering a wide driveway on Stonewall Jackson Drive, visitors are greeted with birdsong and chirping of crickets. The Songbird Habitat has a Meadow Trail and Woods Trail, each a one-mile loop. Both are unusually tranquil and have convenient benches for walkers to stop and soak up the natural tranquility. Trails are easy hikes in both meadow and woods. Dogs are not allowed in this fine songbird environment. Georgia's state bird brown thrashers and their northern mockingbird cousins are there. Both feed on wild fruits, aggressively chase threats in their areas and are excellent singers. Mockingbirds are nature's veritable jukebox and can remember two hundred or so songs, including mimicry of insect, frog and even machine sounds.

A familiar directional sign along Songbird Trail. *Photo by authors.*

Various songbird inhabitants include Carolina chickadees, which remain year round roosting in tree cavities, lowering body temperatures in winter to induce hypothermia. American goldfinches, with their bright yellow feathers, are noticeable in spring and summer with their feisty little territorial "colonies" of two or three birds. Foraging songbirds that croon an infectious backbeat include American bluebirds, yellow breasted chats, indigo buntings and blue grosbeaks.

The Songbird Habitat has "maximized edges" as the meadows and field fade to the Woods Trail, with trees as a backdrop. The Woods Trail winds through a mature forest with maples, cedars, rosebud, crabapple and, because it is Stone Mountain, some impressive granite outcrops that grow on visitors to the park because of the sense of place they create. Don't miss the viewing platform from the Woods Trail that looks down a long low hill on the grassy, flowery Meadow Trail. Finishing these gentle hikes, in a stretch of piney woods, the mountain rears up for a spectacular view. The spirit of Olympic competition that once pervaded Stone Mountain in 1996 has morphed into the songbird environment.

MOUNTAINTOP HABITAT

The mountain summit, visited by usually elated people who have hiked or ridden the Skylift there, has a subtle, fragile ecosystem that is not readily apparent.

Award-winning photo of a rock pool on the Stone Mountain summit. *Photo by Jamonica Lynn Downing.*

A Stone Mountain slope with a barren granite environment, which sometimes has desert-like heat and frigid temperatures yet fosters natural habitats. *Jennifer J. Richardson Collection.*

Much of the tenuous natural life at the mountaintop lives in austere stone pools, depressions deep enough to collect water. Few organisms can live in such highly acidic, low-nutrient environments filled with ice in winter and bone dry in summer. Some organisms found in Stone Mountain pools include Stone Mountain clam shrimp, barely visible in spring and summer. When mountain pools dry, shrimp eggs remain in granite dust until favorable temperatures incite hatching. Fairy shrimp can no longer be found in the habitat. Pool sprites are rare, endangered annual plants found only in stone pools. When water dries, pool sprites die, but their seeds last through summer, germinating in cool weather and flowering in March. Environmentalists at Stone Mountain Park are reintroducing another small pool plant, the black-spored quillwort, which has leaves like needles.

A TIMELESS VIEW:
RED-TAILED HAWKS OVER STONE MOUNTAIN

It is natural to lie down on the warm granite on the mountaintop on a nice day to watch clouds, where often one's attention may be drawn to large, high-flying birds circling overhead. Black and turkey vultures, nature's clean-

Magnificent red-tailed hawk of the type at Stone Mountain, rendered artistically. *Photo and sculpture © Bernie Jestrabek-Hart, Nampa, Idaho.*

up crew, speed through columns of warm air, thermals, and locate dead animals by smell, scavenging them. More regal, however, are the red-tailed hawks that swoop down to prey on rodents, bats, snakes, waterfowl, fish and jackrabbits, killing with strong talons and sharp beaks, sometimes even preying on birds in flight. These soaring monarchs of the sky have sharp eyesight that is legendary, said to be eight times better than a human, hence the expression "eyes like a hawk."

These majestic hawks—which in a sense at Stone Mountain are Atlanta falcons—are monogamous in a variety of habitats, mating for life, as described by Marie Winn in her touching *Red-Tails in Love: A Wildlife Drama in Central Park* (1998). Hawk couples defend nesting territory for years, so the park has its own resident raptors. Boldly heralding their appearance with a hoarse *kree-eee-ar*, sounding almost like a steam whistle, the magnificent birds of prey command one's attention. The abundant ecosystem of Stone Mountain Park makes it a natural domain.

Legally protected by international treaties, red-tailed hawks have wingspans of about fifty-seven inches. Markings and hues vary somewhat among subspecies, but all have lighter underbellies and darker feather

patterns. Their distinctive tails are uniformly brick-red above and pink below, with yellow legs and feet. In flight these hawks soar with deliberate, deep wing beats to conserve energy. In wind they sometimes hover on beating wings to remain stationary above the ground, which is breathtaking to see. Their only rivals are great horned owls, which have nocturnal ecological niches; occasionally over Stone Mountain one sees the two great predators in primal competition at twilight.

Some of the greatest natural sights over Stone Mountain are red-tailed hawk mates performing aerial displays during courtship flights, as both male and female utter their shrill, piercing cries. Male hawks fly steep, fast dives, sometimes up to 120 miles per hour, and then slowly climb again, high above the mountain. After several repeats, he grasps her talons as they fly in midair. This mating ritual often lasts up to ten exciting minutes, and no view is better than that from the Stone Mountain summit. The sight of these noble birds of prey with red tail feathers has been symbolic to Native Americans throughout the ages so much that many tribes still consider this plumage sacred in religious ceremonies. Indeed, red-tailed hawks over Stone Mountain are as timeless today as they have been in ages past.

Notes on Sources

Finest of all experiential sources is Stone Mountain Park itself, where the rich, thoughtful, updated indoor and outdoor museum exhibits, some with films and updated brochures, are produced by the Stone Mountain Memorial Association. The best print source is David B. Freeman, *Carved in Stone: the History of Stone Mountain* (Macon, GA: Mercer University Press, 1997; 200 pp., including illustrations, photographs, bibliography and index), which has exhaustive research. A good review, though dated, by a fine Atlanta writer and journalist is Willard Neal, *The Story of Stone Mountain* (Atlanta, GA: American Lithograph Company, 1963), with his later-edition *Georgia's Stone Mountain* (Stone Mountain, GA: Stone Mountain Memorial Association, 1970). An interesting compendium of local legends is found in Kathryn Patton, *A Sketchbook of Stone Mountain* (Stone Mountain, GA: Sue Kellogg Library, no date). Reliable for traditional history is Franklin M. Garrett, "The Early Days of Stone Mountain," *Georgia* magazine (April–May, 1970). The dedication of the memorial carving led to a rich special edition, although not multicultural, in the *Decatur-DeKalb News*, May 9, 1970. A useful contextual source is Kenneth Coleman et al., *A History of Georgia*, 2nd ed. (Athens: University of Georgia Press, 1991). Some specific dated references in the *Atlanta Journal*, *Atlanta Constitution*, *New York Times* and other publications are sometimes cited directly in our text, as well as authors on specific histories that were useful. Essential to understand the state from geological ages through and beyond the 1996 Olympics is John C. Inscoe, ed., New Georgia Encyclopedia, online (www.georgiaencyclopedia.org). Our approach in the last two chapters was influenced by Georgia Humanities Council, *The New Georgia Guide* (Athens: University of Georgia Press, 1996).

CHAPTER 1

The interactive Confederate Hall Historical and Environmental Educational Center, an outstanding experiential way to study the geological origins of Stone Mountain (reopened in 2004), is advised by the excellent Fernbank Science Center in Atlanta, whose mission is to "promote an understanding of science and technology and to communicate the harmony and order of the natural world." Its displays rendered by Taylor Studios, Inc. (Rantoul, Illinois) are outstanding. A useful geological tutorial is Pamela Gore, "Stone Mountain Field Trip Worksheet" (2009), Georgia Perimeter College website (www.gpc.edu). For Indian notions of creation, see James Mooney, "Myths of the Cherokee" (Washington, D.C.: Smithsonian Institution, 1900) reprinted in "Cherokees and Creeks: Traditional Cultures and the Anglo-Saxon Encounter," Thomas A. Scott, ed., *Cornerstones of Georgia History: Documents that Formed the State* (Athens: University of Georgia Press, 1995).

For unique cosmic multidisciplinary perspectives, see Thornwell Jacobs, *The New Science and the Old Religion* (Oglethorpe University [a suburb of Atlanta], GA: Oglethorpe University Press, 1927), an unusual volume dealing with various geological factors and mythology relating to the overpowering magnificence of the universe. An account of the old "Devil's Crossroads" once atop Stone Mountain is found in Reverend R.F. Goulding, *Sol-O-Quoh; or Boy-Life Among the Cherokees* (New York: Dodd, Mead & Co., 1870). For the oldest Stone Mountain archaeological sites, see Sudha A. Shah and Thomas G. Whitley, *An Overview and Analysis of the Middle Archaic in Georgia* (Atlanta, GA: Brockington and Associates, Inc., 2009, prepared for Georgia Department of Transportation). Max E. White, *The Archaeology and History of the Native Georgia Tribes* (Gainesville: University Press of Florida, 2002) places Indian mountaintop "fortifications" in context, contending that they were more likely ceremonial sites. The Stone Mountain Indian Trails file, DeKalb History Center, Decatur, Georgia, includes monographs by John H. Goff, professor at Emory University and a passionate amateur historian of DeKalb County Indian trails. See also Josephine Severinghaus, "Indian Trails in DeKalb County," *Atlanta Journal*, October 29, 1939, and Janice Royal, "Indian Trails Linger between DeKalb Roads," *DeKalb New Era*, August 9, 1970.

CHAPTER 2

For the Columbian Exchange, see Steven Mintz, ed., *Native American Voices: A History & Anthology* (St. James, NY: Brandywine Press, 1995). Excellent on the Mississippi chiefdoms is Charles Hudson, *Knights of Spain, Warriors of the Sun: Hernando De Soto and the South's Ancient Chiefdoms* (Athens: University of Georgia Press, 1997). Phinizy Spalding relates encounters between Indians and Europeans in *Oglethorpe in America*

(Athens: University of Georgia Press, 1977). The classic autobiographical account of President Washington's representative at Stone Mountain is *Narrative of the Military Actions of Colonel Marinus Willett, Taken Chiefly from His Own Manuscript, Prepared by His Son William M. Willett* (New York: G. & C. & H. Carvill, 1831). This rare volume is in the New York Public Library and may be accessed online (http://babel.hathitrust.org). The fascinating Alexander McGillivray merits a biographical sketch by Michael Green in R. David Edmunds, ed., *American Indian Leaders: Studies in Diversity* (Lincoln: University of Nebraska Press, 1980).

For traditional Atlanta-area settlement and land lots, Garrett's aforementioned "Early Days of Stone Mountain" remains reliable. Much useful information on the Georgia Railroad is in the American Periodical Series Online (http://search.proquest.com/americanperiodicals), which has the *Merchant's Magazine and Commercial Review* (1839–1870) and the *Journal of the Franklin Institute of the State of Pennsylvania*. Extremely interpretive on frontier towns is the section on "The Upstarts" in Daniel Boorstin, *The Americans: The National Experience* (New York: Random House, 1965).

An unusually frank and excellent period memoir is Wendy Venet, ed., *Sam Richards's Civil War Diary: A Chronicle of Atlanta and the Home Front* (Athens: University of Georgia Press, 2009). A lively account of Civil War activity in the extended Stone Mountain area is David S. Evans, "Kennar Garrard's Georgia Romp," *America's Civil War* (March 2002). George Coletti has recently written an epic Civil War novel set in his hometown, *Stone Mountain: The Granite Sentinel* (Stone Mountain, GA: privately published, 2010), that incorporates historical records with excellent images on an accompanying CD. Updated and invaluable is Barry L. Brown and Gordon R. Ewell, *Crossroads of Conflict: A Guide to Civil War Sites in Georgia* (Athens: University of Georgia Press, 2010), a publication of the Georgia Civil War Commission. It is comprehensive, including an excellent section on Stone Mountain. *The Memoirs of William T. Sherman* (New York: Charles L. Webster & Co., 1891) describes Stone Mountain surrounded by flames after the Atlanta Campaign.

Chapter 3

Our overall approach is indebted to John C. Inscoc, ed., *Georgia in Black & White: Explorations in the Race Relations of a Southern State 1865–1950* (Athens: University of Georgia Press, 1994). Stone Mountain City Cemetery can best be studied experientially with the Sons of Confederate Veterans annual tour on Confederate Memorial Day weekend in April, when the cemetery is festooned with flag commemorations and reenactors interpret. The cemetery website (http://files.usgwarchives.net/ga/dekalb/cemeteries/confed.txt) has all of the plaques conveniently transcribed. For background, see the online *Encyclopedia on Death and Dying* (http://www.deathreference.com). Relevant narratives from Georgia on

blacks burying whites are in George P. Rawick, ed., *The American Slave: A Composite Autobiography*, series 1, volumes 12–13 (1941; Westwood, CT: Greenwood Publishing Company, 1972). A classic source from the Confederate perspective is Mary Gay, *Life in Dixie during the War* (1892; Decatur, GA: DeKalb Historical Society, 1979 reprint), employed extensively by Margaret Mitchell in *Gone with the Wind*. Most sophisticated on its topic is Allison Dorsey, *To Build Our Lives Together: Community Formation in Black Atlanta, 1875–1906* (Athens: University of Georgia Press, 2004). Classic black perspectives that have held up extremely well and were used for context include W.E.B. Du Bois, *The Souls of Black Folk* (1903, many editions) and his *Black Reconstruction in America: An Essay Toward a History of the Part Which Black Folk Played in the Attempt to Reconstruct Democracy in America, 1860–1880* (1935; New York: Atheneum, 1985).

Our narrative continues to be informed by Daniel J. Boorstin, *The Americans: The National Experience* (New York: Random House, 1965) on the northern granite industry and the last volume in his trilogy, *The Democratic Experience* (New York: Random House, 1973), in particular his essay on "Cities within Cities." The father of Daniel Boorstin (1914–2004) was a Jewish attorney in Atlanta. He helped defend Leo Frank, and disquieted by reprisals and lack of multicultural toleration in Atlanta, Boorstin relocated his family to Tulsa, Oklahoma, after the Frank lynching. For Samuel Venable, it is useful to visit his granite tomb at Atlanta's Historic Oakland Cemetery and listen to a "teller" relate, at the family mausoleum constructed of Stone Mountain granite, Venable's story researched by Atlantan tour guide Wynn Montgomery. The park quarry exhibit, entitled Raising a Ledge: Stone Mountain Quarrymen and the Granite Industry, is a "must see," enhanced with sounds when the train goes by. There are useful brochures.

Alton Hornsby Jr. writes articulately of education "born segregated" in *Black Power in Dixie: A Political History of African Americans in Atlanta* (Gainesville: University Press of Florida, 2009). For the revival of the KKK, Paul Stephen Hudson and Lora Pond Mirza have an unpublished paper, "Fiery Cross atop Stone Mountain," based on numerous sources and visual images, presented at the 2010 meeting of the Georgia Association of Historians in Decatur. An extremely well-done and exhaustive source on the background to the KKK is Steve Oney, *And the Dead Shall Rise: The Murder of Mary Phagan and the Lynching of Leo Frank* (New York: Pantheon Books, 2003). Valuable to understanding race relations in Atlanta in the early 1900s is Mark Bauerlien, *Negrophobia: A Race Riot in Atlanta, 1906* (San Francisco, CA: Encounter Books, 2001). *I Remember Shermantown: Long-term Residents Share Memories*, a MBF Production (Decatur, Georgia) project initiated by the DeKalb History Center (video, 2005), provides a valuable introduction of the historically black community at Stone Mountain Village. Through several oral histories, it gives a fond sense of what it was like to grow up in that close-knit African American community. Yet personal recollections from other residents and shared with the authors give more insidious views of the Klan. Finally, numerous interviews and statements by citizens old enough to remember the stark

decades of segregation in the Atlanta area revealed heart-wrenching memories. Speaking at the Decatur Book Festival in 2007, for example, the revered octogenarian country doctor and author Ferrol Sams (*Run with the Horseman*), who is white, remarked, "Looking back, I have an overwhelming sense of shame."

Chapter 4

The Stone Mountain Memorial carving has a variety of names. We have opted for the name "Confederate Memorial carving." A good place to view the carving is from the plaza at Memorial Hall, where a tourist kiosk plays reviews in different languages. There is a brochure available, *The History Carving of Georgia's Stone Mountain*, which has a convenient timeline for its long history. Closer views of the carving, impressive when lit at night, come from various vantage points on the Memorial Lawn. It is flanked by flag pavilions for states that seceded from the Union. There are two memorial gardens for the Confederacy down near the carving. A walk around the edge of the Memorial Lawn conveys a fine sense of the Lost Cause and the contention that secession was ostensibly the cause of the Civil War. Gary W. Gallagher and Alan T. Nolan, eds., *The Myth of the Lost Cause and Civil War History* (Bloomington: University of Indiana Press, 2010) offers rich insights into the Confederate memorial mentality. Background on Rabbi David Marx, who delivered the 1925 invocation at the Stone Mountain Memorial, is in Steve Oney, *And the Dead Shall Rise*, referenced earlier. Overall time capsule perspectives are in Paul Stephen Hudson, "Instant Archeology: Time Capsules as Memorial Gestures," *Public Art Review* (Fall–Winter, 1999).

The best source on the history of the Confederate Memorial carving is David B. Freeman, *Carved in Stone: The History of Stone Mountain*, referenced earlier. As his title indicates, Freeman views the memorial carving as the focus of Stone Mountain and dedicates five of his eight chapters in a thorough review of it. He uses primary sources in the Robert W. Woodruff Library, Emory University Stone Mountain Collection, which has materials from 1915 to 1977. Included are records of the Stone Mountain Confederate Monumental Association and papers relating to Gutzon Borglum and his controversial dismissal. The collection also includes sources on the Venable family and its role in having the monument completed with Borglum reinstated as sculptor. The Emory collection also has the papers of C. Helen Plane of the Atlanta branch of the United Daughters of the Confederacy. Borglum's extraordinary 1926 public letter typescript was made available to us by Gary Peet of Stone Mountain. As defined in the Stone Mountain Memorial Association Act, 1958 Ga. Laws 61–81, SMMA is a "body corporate and politic and an instrumentality and public corporation of the State," serving as a "Confederate Memorial and public recreation area."

Unique and unusually candid first-person insights on the completion of the carving are by its consultant in the online Oral History Interview with Walker

Hancock, 1977 July 22–August 15, Archives of American Art, Smithsonian Institution, conducted by Robert Brown: http://www.aaa.si.edu/collections/interviews/oral-history-interview-walker-hancock-13287. It covers Hancock's entire career, with due focus on Stone Mountain. The eleven-minute video at the Memorial Hall theater, *The Men Who Carved Stone Mountain*, is excellent and features vivid vintage images. An invaluable source on the legendary minister who delivered the dedication is Wheat Street Baptist Church, Dr. William Holmes Borders Sr. and Dr. Juel Pate Borders-Benson, eds., *45ᵗʰ Pastoral Anniversary, Reverend William Holmes Borders, 1937–1982* (Atlanta, GA: Josten's American Yearbook Company, 1982). Extremely penetrating revisionist analysis of the carving is in Grace Elizabeth Hale, "Granite Stopped Time: The Stone Mountain Memorial and the Representation of White Southern Identity," *Georgia Historical Quarterly* (Spring 1998).

The Stone Mountain Lasershow Spectacular, presented nearly every summer evening to thousands, is a superb way to see the carving in a popular interactive setting with thousands of people.

CHAPTER 5

Tim Hollis, *Stone Mountain Park* (Charleston, SC: Arcadia Publishing, 2009) is a pictorial book by a historian of tourism who first became fascinated with his subject as a child on a family trip. Freeman, *Carved in Stone*, referenced earlier, contains the useful chapter "A Park for All Seasons," which traces its early history well. Updated historical insights on contemporary America and the South are in William H. Chafe et al., *A History of Our Time* (New York: Oxford University Press, 2008). Fran Fossett wrote a revealing article about the original park museum displays in "Confederate Hall Tells Story of War in Lights, Sound and Pictures," *Decatur-DeKalb News*, May 9, 1970. We continue to use analytical insights of Grace Elizabeth Hale in her "Granite Stopped Time" in *Georgia Historical Quarterly*, referenced earlier. The park has long had brochures on *The Antebellum Plantation*. An archival brochure courtesy of Joe Dabney—collected in a valuable file when he was writing his 1964 Stone Mountain national update piece for the *New York Times* as an Atlanta stringer—is the revealing *Stone Mountain Confederate Memorial Scenic Map 1961–62*. Many biographical views of Butterfly McQueen now see her as a complex artist instead of the caricature Prissy, but few sources interpret her strange time at Stone Mountain Plantation as a life watershed. McQueen is now listed in Edward T. James et al., *Notable American Women: A Biographical Dictionary* (Cambridge, MA: Harvard University Press, 2004). For the Scenic Railroad, useful unattributed articles include "Train Ride Around Stone Mountain" and "Famous Civil War Trains" in *DeKalb New Era*, May 7, 1970, and "Indians Attack: A Ride on the Railroad, Adventurous Family Fun," *Decatur-DeKalb News*, May 9, 1970. On the ancient trail to the top of Stone Mountain, see Vivian

Price, *The History of DeKalb County, Georgia 1822–1900* (Fernandina Beach, FL: Wolfe Publishing Company, 1997).

Many of our sources are experiential, such as attending the Easter sunrise service, walking about reading plaques at sites such as the Grist Mill, Covered Bridge, Carillon Americana, UDC Flag Terrace and countless trips up the Walk-up Trail. Much of the approach here is from a philosopher of sport, George Sheehan, *This Running Life* (New York: Simon & Schuster, 1980). Walks around the terraces surrounding the Memorial Lawn, combined with a reading of Walker Hancock's extended 1977 interview with the Smithsonian Institution, referenced earlier, are highly recommended and lead to many insights. For productive windshield surveys, the SMMA *History and Self-Guiding Tour* pamphlet at Confederate Hall is excellent. The Stone Mountain Park driving map (motto: "One Adventure after Another") is useful also. It lists the laser show schedule and the extensive "World Class Festivals and Special Events" calendar, with a complete list of sights/recreation on a coded map.

For an inside view of the 1996 Olympics, an excellent source is C. Richard Yarbrough, *And They Call Them Games* (Macon, GA: Mercer University Press, 2000). Journalists covered the fascinating story of the track cycling venue at Stone Mountain Park many times, including Debbie Becker, "Maligned Velodrome Now Wins Applause," *USA Today*, July 29, 1996. Design Engineer Chris Nadvoich has published extensively on "A New Generation [of Velodrome]" (http://nadovich.com/chris/track/index.html). Wolfram, which has the license on Mathematica, has various articles, including "Cyclists Break World Records on Olympic Velodrome Built with Mathematica" (http://www.wolfram.com/news/velo2.html). Wolfram dubbed its racing track the "Vanishing Velodrome at the 1996 Olympics" (http://www.wolfram.com).

The outline of the Stone Mountain Park Master Plan is in *Stone Mountain Memorial Association*, a newsletter publication available at Confederate Hall. G. Curtis Branscome, CEO of the Stone Mountain Memorial Association, wrote an eloquent summary of the state of Stone Mountain Park on its fiftieth anniversary in his foreword to the beautiful pictorial source by Larry Winslett, *Stone Mountain: A Walk in the Park* (Dahlonega, GA: Bright Hawk Press, 2007).

CHAPTER 6

Horticulturalist Harold Cox, "Mountain Park Has a Number of Rare Plants," *DeKalb New Era*, May 7, 1970, effectively reveals his voice, and there is a good, unattributed background article, "English Horticulturist Loves Stone Mountain," in that same issue. Harold's daughter, Rosemary Cox, professor of English at Georgia Perimeter College, grew up at Stone Mountain Park when the family moved there in 1961, and she informed us with insights on the park's development. Two excellent illustrative volumes on natural habitats are Larry Winslett, *Stone Mountain: A Walk in the Park*,

referenced above, and his book with wife and collaborator Julie Winslett, *Wildflowers of Stone Mountain: A Field Guide* (Dahlonega, GA: Bright Hawk Press, 2004). The latter helps provide "a historical record of the wildflower species at Stone Mountain Park at the turn of the 21st century." Larry's devotion to the park manifests itself in his marvelous natural photography, and he volunteers as a tour guide for the Cox Nature Trail. In addition to its geological exhibits, the Confederate Hall Historical and Environmental Education Center presents a fine museum section on nature at the park. Since 2004, the center has been educating guests and students on park ecology.

David Smethhurst, in "Mountain Geography," *Geographical Review* (January 2000), offers excellent comparative perspectives. Our main sources again are experiential: hiking the trails many times, gaining familiarity with them and using information furnished by the park. One convenient trail map widely available has skeletal routes of the Cherokee, Nature Garden and Songbird Habitat Trails. They are delightful any time of year, and all have fantastic views of the mountain at various times. The Nature Trail is unusually well interpreted, and to a lesser extent, so is the Songbird Trail. A brochure, *Cherokee Trail at Stone Mountain Park*, is also available on the Stone Mountain Park website and is excellent. On visits to the Quarry Habitat and Top of the Mountain building on the summit, one can encounter vivid natural photographs, many by Larry Winslett, with well-crafted captions. The extensive park campground, beautifully set on Stone Mountain Lake, has a page on the website (http://www.stonemountainpark.com) and a map brochure available. Much has been written about the majestic red-tailed hawk. The Hawk Conservancy Trust (http://www.hawk-conservancy.org) and the San Francisco State University Department of Geography & Human Environmental Studies (http://bss.sfsu.edu/geog) are both useful. The Cornell University Ornithology Lab website (http://www.birds.cornell.edu) is excellent on red-tailed hawks and includes samples of their distinctive cry. Bernie Jestrabek-Hart, of Nampa, Idaho, the creator of detailed, meticulously crafted red-tailed hawk sculptures, brought to our attention the magnificent Burke Museum of Natural History and Culture, University of Washington, Seattle (http://www.washington.edu/burkemuseum). The Burke Museum has an internationally recognized collection of bird wings.

Index

About the Authors

Paul Hudson and Lora Mirza are faculty members at Georgia Perimeter College in Atlanta, Georgia. He teaches history and is also a monthly columnist for six papers in metro Atlanta published by Hometown News. She teaches public services in libraries and is a research librarian and photographer, with a background in publishing. Paul served on the board of the local DeKalb History Center, and Lora

Lora Mirza and Paul Hudson at Georgia Perimeter College library. *Photo by Julie Jarrard.*

is on the editorial board of the *Georgia Library Quarterly*. Paul frequently hikes at Stone Mountain. Lora and her husband, Usman, took their now grown children, Taric and Adam, to outings at Stone Mountain Park for years and continue to take many international visitors to the park. Both Paul and Lora buy their annual Stone Mountain Park unlimited entrance passes every year.